NI
COOLP

THE EXPANDED GUIDE

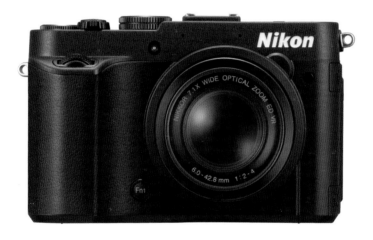

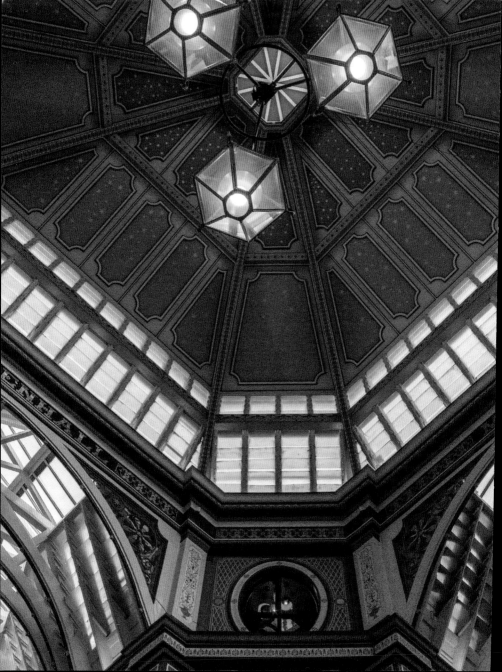

NIKON
COOLPIX P7700

THE EXPANDED GUIDE

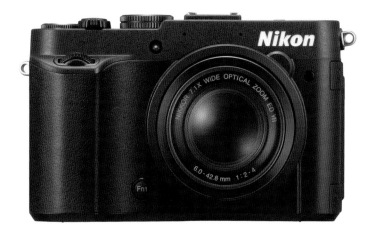

Jon Sparks

AMMONITE
PRESS

First published 2013 by
Ammonite Press
an imprint of AE Publications Ltd
166 High Street, Lewes, East Sussex, BN7 1XU, UK

ISBN 978-1-90770-899-2

British Library Cataloging in Publication Data: A catalog
record of this book is available from the British Library.

Editor: Rob Yarham
Series Editor: Richard Wiles
Design: Fineline Studios

Typefaces: Giacomo
Color reproduction by GMC Reprographics
Printed in China

« PAGE 2
LEADENHALL MARKET
In city shooting, it often pays
to look up. I'd have liked a
wider-angle lens, but was
still pretty happy with the
framing here. *ISO 1600,
28mm, 1/60 sec., f/8.*

» CONTENTS

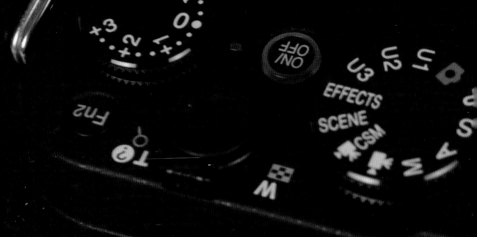

Chapter 1
OVERVIEW

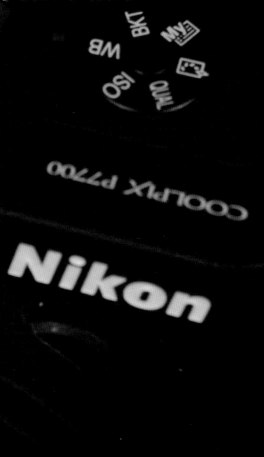

1 OVERVIEW

The Nikon P7700 is Nikon's latest flagship compact camera, and its most accomplished model yet in this sector. It combines rugged build quality and excellent handling with impressive image quality.

» HISTORY

Nikon is one of the world's leading makers of cameras and other optical equipment. For many decades "Nikon" was a brand name solely for cameras, the company itself being called Nippon Kogaku (Japan Optical), but it was renamed Nikon Corporation in 1988. The company produced its first cameras just after World War II; those early models were heavily influenced by European makes such as Leica and Contax, but the company soon progressed from copycat to innovator. The Nikon F, launched in 1959, was by no means the first 35mm SLR (single lens reflex) camera, but it was arguably the first really viable example. As such, it is one of the most significant cameras in history.

35mm SLRs remained dominant in both professional and enthusiast spheres for over 40 years, but when things began to change Nikon were again at the forefront. As with the Nikon F, 1999's Nikon D1 was not the first digital SLR, but it was the first to combine acceptable levels of speed and performance with manageable weight and bulk. Like the Nikon F, it was a game-changer.

The first Nikon Coolpix "consumer" camera had already appeared in 1997. The Coolpix 100 had a fixed 52mm (equivalent) lens and just 0.3-megapixel resolution. Since then, well over 100 models have carried the Coolpix name. From 2005, the series has been segmented into three distinct sub-brands, denoted by the initial S (for "style"), L (for "life") or P (for "performance"). The first cameras to carry the P prefix were the P1 and P2, launched

simultaneously in the same year, followed within six months by the P3 and P4. All offered inbuilt WiFi connectivity (subsequently quietly dropped) and the P3/P4 also pioneered Nikon's Vibration Reduction technology for sharper images in handheld shooting.

Though capable, these cameras were perhaps less fully featured than serious enthusiasts may have wished, and the direct lineage of the P7700 is more evident in the P5000, launched in 2007. Its control layout was distinctly reminiscent of Nikon DSLRs, underlining that it was aimed at photographers who value control and prefer key settings to be readily accessible, rather than hidden in menus. The P5100,

appearing just six months later, was essentially a minor upgrade, though substantial hype surrounded its jump from 10 to 12 megapixels.

There was a further rise in the megapixel count (13.5) when the P6000 appeared in 2008, but this trend was sharply reversed with the advent of the P7000 in 2010, dropping back to a "mere" 10.1 megapixels. This apparently modest figure was retained for the P7100. The P7700 takes the count back up to 12, but there are many compact cameras boasting 14, 16, or 18 megapixels. As there's a widespread view that more megapixels must be better, this deserves further examination.

THE LEGENDARY NIKON D1 ❯❯
Nikon's landmark digital SLR.

NIKON COOLPIX P5000 ❯❯
The P7700's ancestor, launched in 2007.

1 » BUSTING THE MEGAPIXEL MYTH

There is far more to image quality than the crude indicator that is the number of megapixels. In fact, there's a strong argument that some restraint in megapixel numbers leads to measurable improvements in real image quality.

The sensor (the digital chip which captures light to form the image) in cameras like this is tiny: in the P7700, and many of its direct competitors, it measures just 0.3 x 0.2in (7.5 x 5.6mm). The actual photosites (light-receptors) are microscopic, and cramming more of them onto the same size of sensor makes them even smaller. This physically limits how much light strikes any one photosite. Other things being equal, larger photosites will perform better in relation to image noise and dynamic range (the ability to capture detail in both bright highlights and deep shadows), and allow the camera to shoot good-quality images at high ISO ratings. For 99.9% of photographers, these features are what counts for real-world image quality, not superfluous megapixels.

› Unfair comparisons

DSLR cameras have physically much larger sensors; in most of Nikon's DSLR range they measure around 0.9 x 0.6in (23.6 x 15.6mm), giving them approximately nine times the area of the sensor in the P7700. Even with significantly more megapixels (24 or so in cameras like the D3200 and D5200), the light-gathering area per pixel is much larger and performance in areas like noise, dynamic range, and high-ISO ability is correspondingly superior. The downside, of course, is that the cameras—and especially the lenses—are considerably bigger and heavier.

MAKING SENSORS ❮❮

A comparison of Nikon camera sensor sizes.

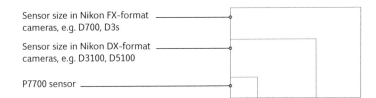

Sensor size in Nikon FX-format cameras, e.g. D700, D3s

Sensor size in Nikon DX-format cameras, e.g. D3100, D5100

P7700 sensor

» ABOUT THE NIKON P7700

By today's standards, the Nikon P7700 is on the large side for a "compact" camera, but for good reasons. Unlike previous models, there's no longer an optical viewfinder to be accommodated, but its dimensions allow the camera to be furnished with a generous number of external control dials and buttons around its large 3in. (75mm) LCD screen. In addition, it has a reassuringly rugged feel which indicates excellent build quality.

The camera is designed to appeal to experienced users and therefore offers a high level of quick and easy controllability. For example, when shooting in Manual (M) mode, both shutter speed and aperture can be set instantly by turning one or other of the command dials: this instant fingertip control is not just lacking on most compacts, it's even—sadly—absent from many entry-level DSLRs, including Nikon's own.

Key features include a 7x zoom lens (28–200mm equivalent) with a wide f/2 aperture at 28mm (at 200mm it's a more modest f/4). Shutter speeds run from 60 seconds to 1/4000 second while the ISO range extends from 80 to 6400. As befits a serious camera, the P7700 can shoot RAW format images. With no optical viewfinder, the P7700 relies solely on its fully articulating, 921,000-dot LCD screen. The P7700 can shoot Full HD (1920 x 1080) movie clips.

The *Expanded Guide to the Nikon P7700* will guide you through all significant aspects of the camera's operation.

SWANNING ABOUT »
The P7700's 28–200mm equivalent zoom lens is useful for capturing a wide range of shots when you're out and about. *ISO 400, 105mm, 1/250 sec., f/4.5.*

1 » MAIN FEATURES

Sensor
12.2 effective megapixel 1/1.7in. (7.44 x 5.58mm) RGB CMOS sensor and producing maximum image size of 4000 x 3000 pixels.

Image processor
EXPEED C2 image processing system.

Focusing
Nine-area contrast-detect autofocus system with five focus modes: (AF) autofocus; 🌷 Close range only; 🌷 Macro close-up; ▲ Infinity; and (MF) Manual focus. Seven AF-area modes: Face priority; Manual; Center (normal); Center (wide); Subject tracking; Target finding. Auto setting automatically selects from these. Focus lock.

Exposure
Three metering modes: 256-segment matrix metering; center-weighted metering; spot. Shooting modes include: Auto, 18 Scene modes (plus Scene auto selector): Portrait; Landscape; Sports; Night portrait; Party/indoor; Beach; Snow; Sunset; Dusk/dawn; Night landscape; Close-up; Food; Museum; Fireworks show; Black and white copy; Backlighting; Panorama; Pet portrait; 3D Photography. Four user-controlled modes: (P) Programmed auto; (A) Aperture-priority auto; (S) Shutter-priority auto; (M) Manual.

ISO range between 80 and 3200, with extension to 6400. Exposure compensation between –3 Ev and +3 Ev; exposure bracketing facility.

Shutter
Shutter speeds from 1/4000 sec. to 60 sec., plus B. Maximum frame rate 8fps.

LCD monitor
Fully articulating 3in. (75mm), 921,000-dot TFT LCD display with 100% frame coverage.

Movie Mode
Movie capture in .MOV format with image size of: HD 1080p (1920 x 1080 pixels); HD 720p (1280 x 720 pixels); VGA (640 x 480 pixels).

Buffer
Buffer capacity allows up to 6 frames to be captured in a continuous burst at 8fps. At 1fps, up to 30 full-size images can be shot continuously.

Built-in flash
Pop-up flash (manually activated) with Guide Number of approx. 7 (m) or 23 (ft.) at ISO 100. Up to six flash modes (dependent on Shooting mode in use): Auto; Auto with red-eye reduction; Fill flash: Manual; Slow sync; Rear-curtain sync. Flash compensation from –2 to +2 Ev.

Accessory flash

Hotshoe allows use of Nikon Speedlights and third-party flash units. Built-in flash can be used as commander to activate and control external Nikon Speedlights.

File formats

The P7700 supports NRW (RAW) and JPEG (Fine/Normal/Basic) file formats plus .MOV movie format and MPO 3D pictures.

Lens

Non-interchangeable 6.0-42.6mm zoom lens (35mm equivalent 28-200mm). Maximum aperture: f/2-f/4. Digital zoom 4x (stills); 2x (movies).

Software

Supplied with Nikon View NX2; compatible with Nikon Capture NX2 and many third-party imaging applications.

Storage

Approximately 86 MB internal memory; card slot for SD/SDHC/SDXC memory cards.

FOREST COLORS ❯❯

The P7700's compact size doesn't mean you have to compromise on the quality of your images. *ISO 100, 50mm, 1/8 sec. (tripod), f/5.6.*

1 » FULL FEATURES AND CAMERA LAYOUT

FRONT OF CAMERA

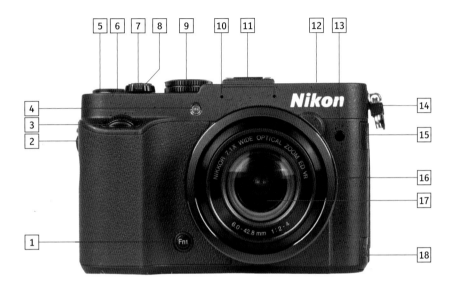

1	Fn1 (function 1) button	10	Built-in microphone (stereo)
2	Eyelet for camera strap	11	Accessory hotshoe
3	Sub-command Dial	12	Built-in flash
4	Self-timer lamp/AF-assist illuminator	13	Infrared receiver (front)
5	Fn2 (function 2) button	14	Eyelet for camera strap
6	Exposure compensation dial	15	External microphone connector
7	Shutter-release button	16	Lens ring
8	Zoom control	17	Lens
9	Mode Dial	18	Accessory terminal

BACK OF CAMERA

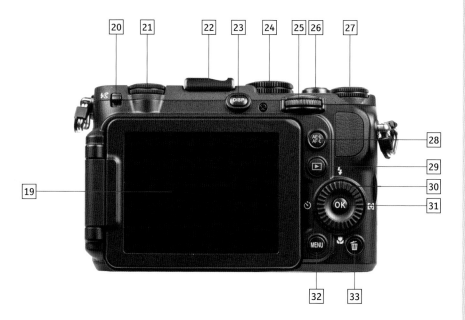

19	Monitor	27	Exposure compensation dial
20	Flash pop-up control	28	AE-L/AF-L button
21	Quick Menu Dial	29	Playback button
22	Accessory hotshoe cover	30	Rotary Multi-selector
23	DISP (display) button	31	OK (apply selection) button
24	Mode Dial	32	MENU button
25	Main Command Dial	33	Delete button
26	Shutter-release button		

1 » FULL FEATURES AND CAMERA LAYOUT

TOP OF CAMERA **LEFT SIDE**

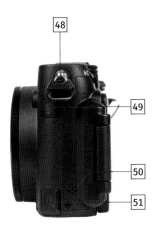

34 Built-in flash	**42** Quick Menu Dial	**48** Camera strap mount	
35 Accessory hotshoe cover	**43** Quick Menu Dial mark	**49** External microphone connector	
36 Mode Dial	**44** Main Command Dial	**50** Speaker	
37 Shutter-release button	**45** Power switch/ power-on lamp	**51** Accessory terminal	
38 Zoom control	**46** Exposure compensation dial mark		
39 Sub-command Dial	**47** Exposure compensation dial		
40 Fn2 (function 2) button			
41 Quick Menu button			

BOTTOM OF CAMERA **RIGHT SIDE**

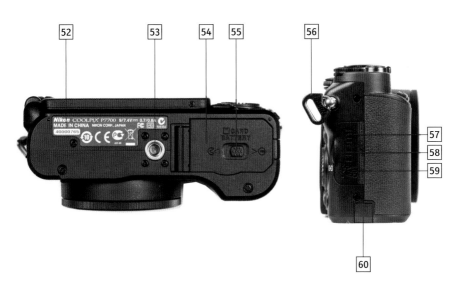

52	Camera serial number
53	Tripod socket (¼in)
54	Battery chamber/memory card slot cover
55	Cover release lever

56	Camera strap mount
57	HDMI mini-pin connector
58	Connector cover
59	USB/Audio video connector
60	Power connector cover

1 » SHOOTING INFO DISPLAY

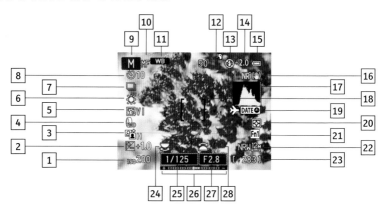

1 ISO sensitivity	**11** Focus indicator/Quick Menu Dial indicator/ Zoom indicator/Zoom memory/Zoom speed setting/AE/AF-L indicator	**20** Metering
2 Exposure compensation value		**21** Fn1 guide display
3 Active D-Lighting		**22** Image quality/Image size/Easy panorama/ Movie options
4 Built-in ND filter	**12** Speedlight	
5 COOLPIX Picture control	**13** Flash mode	**23** Number of exposures remaining
6 White balance	**14** Flash exposure compensation	
7 Continuous shooting mode/Backlighting (HDR)/Auto bracketing/ Handheld/Tripod/Self timer/Remote control		**24** Main Command Dial adjustment indicator
	15 Battery level indicator	
	16 Vibration reduction icon/Eye-Fi communication indicator/Distortion control/GPS reception/ Noise reduction filter	**25** Shutter speed
		26 Exposure indicator
8 Smile timer /Pet portrait auto release		**27** Aperture value
		28 Sub-command Dial adjustment indicator
9 Shooting mode	**17** View/hide histograms	
10 Focus mode	**18** Focus area (for center)	
	19 "Date not set" indicator/ Travel destination indicator/Print date	

» PLAYBACK SCREEN

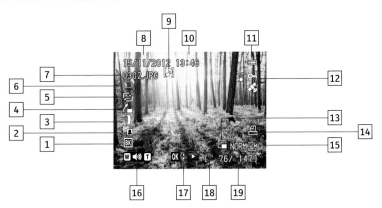

1	Black border indicator	**9**	Voice memo indicator	**17**	Easy panorama playback guide/Sequence playback guide/Movie playback guide
2	D-Lighting icon/Quick retouch icon	**10**	Time of recording		
		11	Battery level indicator		
3	Filter effects icon	**12**	Protect icon/Eye-Fi communication indicator	**18**	Internal memory indicator
4	Straighten indicator				
5	Skin softening icon			**19**	Current image number/Total number of images/Movie length
6	Sequence display/3D image indicator	**13**	Small picture/Crop		
		14	Print order icon		
7	File number and type	**15**	Image quality/Image size/Movie options		
8	Date of recording				
		16	Volume indicator		

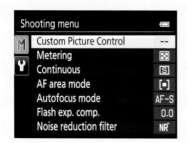

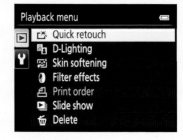

Shooting menu
> Custom Picture Control
> Metering
> Continuous shooting
> AF area mode
> Autofocus mode
> Flash exposure compensation
> Noise reduction filter
> Built-in ND filter
> Distortion control
> Active D-Lighting
> Zoom memory
> Startup zoom position
> M exposure preview
> Focus-coupled metering
> Commander mode

Playback menu
> Quick retouch
> D-Lighting
> Skin softening
> Filter effects
> Print order
> Slide show
> Delete
> Protect
> Rotate image
> Small picture
> Voice memo
> Copy
> Black border
> Straighten
> NRW (RAW) processing
> Sequence display options
> Choose key picture

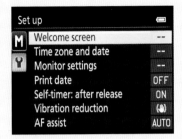

Setup menu
- › Welcome screen
- › Time zone and date
- › Monitor settings
- › Print date
- › Self-timer: after release
- › Vibration reduction
- › Motion detection
- › AF assist
- › ISO sensitivity step value
- › Digital zoom
- › Zoom speed
- › Fixed aperture
- › Sound settings
- › Record orientation
- › Rotate tall
- › Auto off
- › Format card
- › Language
- › TV settings
- › External mic sensitivity
- › Customize command dials
- › Command dial rotation
- › Multi-selector right press
- › Delete button options
- › AE/AF lock button

- › Fn1 + shutter button
- › Fn1 + command dial
- › Fn1 + selector dial
- › Fn1 guide display
- › Fn2 button
- › Customize My Menu
- › Reset file numbering
- › GPS options
- › Eye-Fi upload
- › MF distance indicator units
- › Reverse indicators
- › Flash control
- › Reset all
- › Firmware version

Movie menu
- › Autofocus mode
- › Wind noise reduction

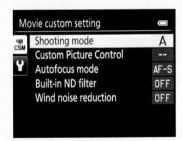

Movie custom setting menu
- › Shooting mode
- › Custom Picture Control
- › Autofocus mode
- › Built-in ND filter
- › Wind noise reduction

Chapter 2
FUNCTIONS

2 FUNCTIONS

With much of its surface covered in buttons and dials, the Nikon P7700 naturally appears complex. However, many digital cameras have just as many options and controls, but hide more of them away in menus. The P7700 puts more of its controls on the surface, making them more accessible and faster to operate. It's not compulsory to use any of them: you could leave the camera at default settings and never touch any of the other controls. But this would waste most of the P7700's considerable potential. This chapter provides a step-by-step introduction to its most important features and functions.

FAMILIARIZATION ⌄
When you unpack a new camera, it's tempting to start shooting right away—and taking pictures is the best way to learn. However, it still makes sense to peruse this book first, to ensure you don't miss out on new features and functions. *ISO 200, 35mm, 1/400 sec., f/5.6.*

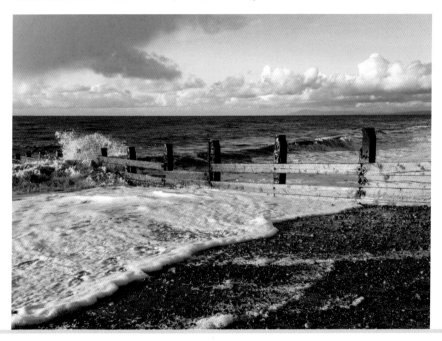

» CAMERA PREPARATION

The camera cannot be used without charging and inserting a battery. Attaching a strap and inserting a memory card are also essential operations. On first use, the camera will prompt you to set the time, date, and time zone (see under Setup menu on *page 112*).

› Battery charging

The Nikon P7700 is supplied with an EN-EL14 li-ion rechargeable battery. This needs to be fully charged before first use. Remove the terminal cover from the battery. Insert the battery into the supplied MH-24 charger, with the maker's name uppermost and terminals facing the contacts on the charger. Press the battery gently into position. Plug the charger into a mains outlet. A lamp will blink during charging, then shine steadily when charging is complete. A discharged battery will take around 90 minutes to recharge fully.

Tip

The printed manual supplied with the camera is a cut-down version: a more comprehensive Reference Manual can be downloaded from the Nikon website.

› Inserting the battery

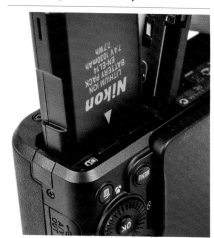

1) Switch OFF the camera.

2) Invert the camera and release the catch on the battery/card-slot compartment cover. Open the cover.

3) Insert the battery, contacts first, with the side labelled "Nikon" facing the rear of the camera, nudging the orange battery latch aside. Slide the battery in until the latch locks into position.

4) Shut the compartment cover, and secure with the catch.

› Battery life

Factors which can reduce battery life include: excessive use of the LCD screen, e.g. reviewing every image; heavy use of the built-in flash; lots of movie shooting.

Under standard test conditions (CIPA) the P7700 delivers around 350 shots from a fully charged battery, but careful use can improve this figure. The Information Display gives an approximate indication of how much charge remains.

For information on alternative power-sources, see Accessories, Chapter 7, *page 210.*

Tip

The battery charger can be used abroad (100–240 V AC 50/60 Hz) with a commercially available travel plug-adapter. Do not attach a voltage transformer as this may damage the battery charger.

› Switching the camera on

Press and briefly hold the On/Off button, behind the shutter-release button, to turn the camera ON. The lens extends automatically. Note: if the screen is folded away the camera will not power on.

You can also switch on by pressing and holding ▶ for a few seconds. This activates the playback display but does not extend the lens. If you then press the shutter-release button, the lens will extend and the camera will be ready to shoot.

› Standby and Auto-off

To conserve the battery, the camera will
enter standby mode after about one
minute if you don't touch any controls.
In standby, the surround of the On/Off
button flashes green. After another three
minutes of inactivity the camera will turn
off completely. The initial one-minute
interval can be changed in the Setup
menu (*see page 119*).

In standby mode, you can reactivate
the camera by pressing the shutter-release
button, On/Off button, or ▶ .

› Attaching the strap

Attach either end to one of the eyelets at
top left and right of the camera. Loosen
the strap where it runs through the buckle,
then pass the end of the strap through the
eyelet and back through the buckle. Bring
the end of the strap back through the
buckle, under the first length of strap
already threaded (*see photo*). Repeat the
operation on the other side. Adjust the
length to suit, but ensure at least 2in. (5cm)
of strap extends beyond the buckle on
each side to avoid any risk of it working
loose. Finally, pull firmly to seat it securely
within the buckle.

ATTACHING THE STRAP ⌃
On one side, the strap is shown ready for use; on
the other, it is threaded but not yet tightened.

> **Note:**
> This method differs from that in the
> Nikon manual, but is more secure
> and neater.

› Inserting and removing memory cards

INSERTING A MEMORY CARD ⌃

The P7700 has a small amount of internal memory, but extensive shooting requires a memory card. It takes Secure Digital (SD) cards, including SDHC and SDXC cards.

1) Switch OFF the camera.

2) Invert the camera and release the latch on the battery/card-slot compartment cover. Open the cover.

3) To remove a memory card, press it gently into its slot, until it springs out slightly. Gently lift out the card.

4) Insert a new card with its label side facing the rear of the camera, and the rows of terminals along the card edge facing into the slot. Gently push it into the slot until it clicks home.

5) Close the compartment cover and secure the latch.

› Formatting a memory card

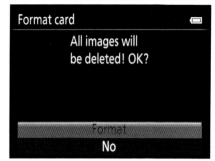

New memory cards, or ones which have been used in other cameras, should be formatted before use with the P7700. Formatting is also the quickest way to erase any existing images; this is useful when reusing a card, but proceed with caution: ensure images have been saved elsewhere before formatting.

To format a memory card

1) Press **MENU** and then select the Setup menu **Y** from the symbols at left of the screen.

2) Select **Format card** and press **OK**.

3) Select **Format** and press **OK**.

» BASIC CAMERA FUNCTIONS

With strap, battery, and memory card on board, the P7700 is ready to shoot. When first switched on, the camera will be set to its basic Auto mode and, if you wish, you can simply start shooting. The first control you'll need is the shutter-release button.

› Operating the shutter

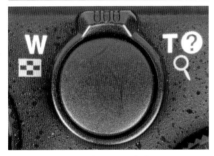

The shutter-release button, with the zoom control around it

The shutter-release button operates in two stages. Pressing it lightly, until you feel initial resistance, activates the metering and focus functions. This half-pressure also cancels active menus or image playback, making the P7700 ready to shoot. Press down further to take a picture.

As soon as you're ready to change any settings, review, or playback your shots, or shoot movies, you'll need to use the appropriate controls and, in most cases, refer to the LCD screen.

Tip

Although the P7700 has an inbuilt Vibration Reduction system to minimize the blurring effect of shake and wobble, it's still best to make your own handling as steady as possible. Don't jab the button: press firmly but smoothly.

› Mode Dial

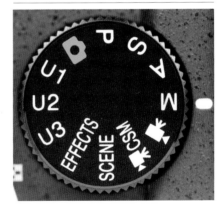

The Mode Dial is the logical next stop. It has 12 positions, including the initial default Auto mode. There are also four User-control modes, Scene modes, Effects, Movie, Movie CSM, and three User settings positions. For a full run-down of these see under Shooting modes (*on page 44*).

2

As you begin to explore a wider range of options, the key controls are the Mode Dial, command dials and Multi-selector, plus the Quick Menu Dial and **MENU** button.

Settings which are affected by these controls are seen in the Information Display (*see page 18*) on the rear LCD screen. However, in Auto and Scene modes it is perfectly possible (though not necessarily recommended!) to shoot without reference to any of these displays or controls. The only real exception is the Menu button, as you'll need to use this to select the appropriate Scene mode (*see page 46*).

› Using the LCD screen

To use the screen, pull its right edge away from the camera. The screen can be angled and rotated to a wide range of positions, which can often be very convenient, but it is more vulnerable to damage when away from the camera body.

For normal use, open the screen out, rotate it 180° (push the top away from you) then fold it back into place against the camera body. Leaving the screen in this position speeds things up, but leaves it vulnerable to scratches and other damage. It's better to get in the habit of stowing the screen away when transporting or storing the camera.

When the camera is active, the monitor shows a live preview of the scene. This can be overlaid with a range of shooting information; press the **DISP** button to toggle between detailed info (the **Show Info** setting) and minimal info (the **Hide Info** setting), a third time to turn off the monitor. You can choose whether to show or hide certain additional indicators on either of these screens, using **Monitor settings** in the Setup menu (*see page 113*). If you turn off all the indicators for **Hide Info**, the screen shows nothing but the preview image.

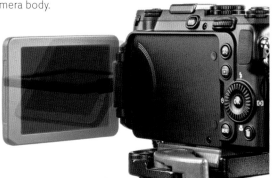

WIDE-SCREEN »
The screen can take a
range of positions.

» LENS

The lens on the P7700 has a 7.1x zoom range, from 28mm to 200mm (in the customary 35mm-equivalent terms). The best way to get a sense of what these figures mean is, of course, to use the zoom; the view changes accordingly on the LCD screen. See also the example photos *on page 147*, and the discussion on preceding pages.

The zoom control is on top of the camera, surrounding the shutter-release button, and falls readily under the right index finger in normal shooting. Normally, when you switch on the camera, the lens will initially be at the 28mm setting. To zoom in, towards the telephoto (200mm) setting, move the control to the right (marked "T"); to zoom back out, move it to the left (marked "W"). An indicator appears on the LCD screen when you zoom the

Using the zoom control

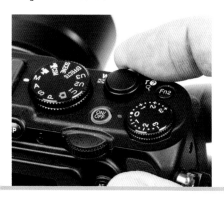

lens, showing approximately where you are in the zoom range.

If you hold the control to left or right, the lens will zoom smoothly and continuously through its range, but you can also make it zoom in steps by pushing and releasing the control. If you hold the Fn1 button as you do this, the camera will zoom to specific preset focal lengths (*see page 102*).

› Digital zoom

Unlike the normal zoom action described above, which physically manipulates the optics of the lens itself ("optical zoom"), digital zoom works by taking the image from a reduced area of the sensor. This mimics the process of cropping which you can perform in a photo-editing app on the computer; a more accurate name would be "in-camera cropping." Digital zoom adds a maximum 4x zoom to the existing range, taking the effective focal length to 800mm. It's impossible to handhold really steadily at 800mm—a tripod or other solid support becomes essential.

Because it's taking the image from less of the sensor, the camera has to fill in missing pixels to recreate a full-size image, a process known as interpolation. This inevitably results in a decline in image quality. However, if you have **Image Size**

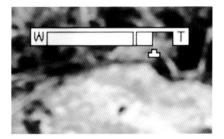

The digital zoom indicator ⌃

Tip

*Digital zoom can't be used when Image Quality is set to **NRW (RAW)**, or when Focus mode is set to Manual Focus or* 🌷 *Macro close-up*

(*see page 36*) set to one of the smaller settings, less (or no) interpolation is needed and digital zoom can go further without harming the image.

As extra insurance, you can set the **Digital zoom** item in the Setup menu (*see page 116*) to **Crop**. This limits the digital zoom range so that interpolation is not required; digital zoom will not go beyond the limit indicated by the ⌁ icon on the LCD screen. This means digital zoom will only operate when image size is set to **5m** or smaller.

Digital zoom's greatest value is when shooting movies, where the effective image size is small anyway, and you can't crop the image on the computer.

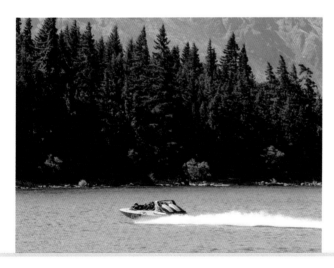

ZOOM «
Digital zoom offers the effect of a very long lens, but the image size is smaller. *ISO 400, 300mm equivalent, 1/1000 sec., f/8.*

» OTHER CONTROLS

› Mode Dial

Already introduced, the Mode Dial has
12 positions, including Auto mode, four
User-control modes, Scene modes, Effects,
Movie/Movie CSM, and User-settings.
There's a complete list under Shooting
modes (*see page 44*), and we'll then go on
to look at each of them individually.

The Main Command Dial

› Command dials

The Main Command Dial falls naturally
under the right thumb when the camera is
in shooting position. The Sub-command
Dial, on the front of the camera, is easily
accessible to the index finger. These dials
are mainly used when shooting in User-
control modes Program (P), Aperture-
priority (A), Shutter-priority (S), and
Manual (M). In other modes, the Main
Command Dial can be used to change a
few settings in the Quick menu.

The Sub-command Dial

Operating the command dials

In A, S, and M modes, the command dials
are used for direct selection of shutter
speed and/or aperture.

Mode	Main Command Dial rotation changes	Sub-command Dial rotation changes
Shutter-priority (S)	Shutter speed	No effect
Aperture-priority (A)	No effect	Aperture
Manual (M)	Shutter speed	Aperture

In program mode (P) the Main Command Dial engages flexible program, cycling
through available combinations of shutter speed and aperture. For more information
on the use of the dials in these modes *see pages 69 to 75*.

› Multi-selector

› MENU button

As the name may suggest, the Multi-selector is a particularly versatile control, used when shooting, during playback and for navigating through the menus. The **OK** button at its center is used to confirm settings.

When shooting, pressing one of the four cardinal points around the selector brings up available options for: ⚡ flash, ⊞ metering, 🌷 focusing, ⏱ timers/remote control. You can then either press the selector up or down, or rotate its outer margin, to scroll through the options; press the **OK** button at its center to confirm your choice.

The **MENU** button is the gateway to a very wide range of options, but some users will scarcely touch most of them. However, even if you do little else with it, it is important as the access point for choosing Scene modes (*see page 46*). Pressing **MENU** brings up an initial screen with (normally) two tabs highlighted at the left side. The lower one is the Setup menu. The function of the upper tab is context-sensitive, i.e. it changes according to which shooting mode the camera is in. In 📷 Auto mode it disappears completely and only the Setup menu is available.

For more on the menus see detailed coverage starting *on page 96*.

» QUICK MENU

The Quick Menu provides rapid access to a number of key settings. However, most of these can only be accessed when the Mode Dial is in P, S, A, or M position. In Scene and Effects modes, the only option where you can make changes is Image Quality (and even then you can't select RAW options). If the Mode Dial is set to Movie, Image Quality changes to Movie Settings (*see page 197*). The other option available for changes in Movie mode is White Balance.

Using the Quick Menu

1) Turn the Quick Menu Dial to the required position. (Pressing the button at its center also activates the menu.)

2) A list of menu headings appears. Scroll through with the Multi-selector.

3) In some cases, a list of options appears across the bottom of the screen; use the Main Command Dial to move through these.

4) Highlight the required setting then press **OK** to make it effective

› Image size and quality

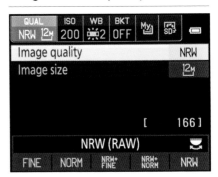

Image quality

"Image quality" refers to the file format, i.e. the way in which image data is recorded. The P7700 offers a choice between NRW (RAW) and JPEG formats. JPEG images are extensively processed by the camera to produce files that should be usable right away (for instance, for direct printing from the memory card), with little or no need for further processing. There are two options for JPEG quality, as shown in the table on the next page.

Image quality options

NRW	12-bit NRW (RAW) files are recorded for ultimate quality and creative flexibility.
FINE	8-bit JPEG files are recorded with a compression ratio of approximately 1:4; should be suitable for larger prints.
NORM (default setting)	8-bit JPEG files are recorded with a compression ratio of approximately 1:8; should be suitable for modest-sized prints and on-screen.
NRW + Fine **NRW + Normal**	Two copies of the same image are recorded simultaneously, one NRW (RAW) and one JPEG (Fine or Normal).

RAW files, on the other hand, record the raw data from the camera's sensor unadulterated, leaving much greater scope for further processing on the computer to achieve exactly the desired result. This requires suitable software like Nikon Capture NX2 or Adobe Lightroom. Because these files preserve the raw data, the generic term for them is RAW or Camera RAW; NRW (RAW) is a specific file format used by Nikon for RAW files.

› Image size

For JPEG files, the P7700 offers multiple image size options, as shown in the table. **12m** is the maximum available size from the P7700's sensor, i.e. 4000 x 3000 pixels, but the smaller sizes are more than adequate for many uses, and allow you to pack more images onto a memory card. For instance, even **4m** size images exceed the maximum resolution of an HD TV, or almost any computer monitor, and can yield reasonable prints up to around 10 x 8 inches (at 200 dpi).

RAW files are always recorded at the maximum size.

Icon	Image size (pixels)	Notes
12m	4000 x 3000	Default setting
8m	3264 x 2448	
4m	2272 x 1704	More than enough to display on HD TV, latest iPad
2m	1600 x 1200	Suitable for many PC monitors, original iPad, iPad mini
VGA	640 x 480	Suitable for standard TV and many mobile devices
3:2	3984 x 2656	Aspect ratio matches 35mm film and many digital SLRs (not available when shooting NRW + JPEG)
16:9	3968 x 2232	Aspect ratio matches widescreen TV (not available when shooting NRW + JPEG)
1:1	3000 x 3000	Square pictures (not available when shooting NRW + JPEG)

Tip

If you aren't sure where your images will end up, it's safer to record them at a larger size. It's easy to resize them down later; pretty well all imaging software packages can do this. On the other hand, up-sizing a too-small image is never really satisfactory.

› ISO

ISO is directly related to exposure and metering, so is covered in more depth *on page 88.*

› White balance

Light sources vary enormously in color. Our eyes and brains are pretty good at compensating for this and seeing things in their "true" colors, so that we nearly always see grass as green, and so on. Digital cameras can also compensate for the varying colors of light and, used correctly, the P7700 can produce natural-looking colors under most conditions.

The P7700 has a sophisticated system for determining white balance automatically, which produces very good results most of the time. For finer control, or for creative effect, the P7700 also offers a range of user-controlled settings, but these are only accessible when using P, S, A, or M modes, or shooting movies.

Most of the White Balance options are fairly self-explanatory, and the LCD screen gives a rough preview of their effect. However, some of the options need more explanation.

Fluorescent (FL1 to FL3)

Fluorescent lamps vary widely in color, and are also among the hardest light sources for Auto White Balance to get right. The sub-settings aim to match commoner varieties of fluorescent lamp, but results are still hit-and-miss, so some trial and error may be necessary. Shooting RAW is a good option, as color can then be freely adjusted later.

Energy-saving bulbs, which are now the norm in domestic use, are compact fluorescent units. They vary widely, but FL2 is probably the best starting point.

Choose color temp.

The color temperature, measured in degrees Kelvin, gives an exact measure of the color of any light source. Knowing the Kelvin value of a light source is a quick way to match it. "Warm White" (830) energy-saving bulbs are rated around 2700K.

Preset Manual White Balance

You can set the white balance to match almost any lighting conditions by taking a reference photo of a neutral white or gray object. This is a complicated procedure which few of us ever use, but if you regularly shoot in a setting with "difficult" lighting it's worth creating and saving a preset. See the Nikon Reference Manual. It's normally much easier to shoot RAW and tweak the white balance later; a reference photo can still be helpful for this. The RAW route is not only easier, it avoids the pitfall that the Preset Manual setting will go on being applied to shots when it's no longer appropriate.

Note:
When shooting RAW images, white balance can be adjusted in post-processing. However, the in-camera setting does affect how images look on playback and review.

Warning!

If images consistently show "wrong" colors on your computer screen, the problem is probably with the screen's settings than with the camera's white balance (see page 224).

Tip

The inside front and back covers of this book are designed to serve as "gray cards," ideal for reference photos for these purposes.

Daylight

Incandescent

Fluorescent FL1

Fluorescent FL3

Cloudy

Flash

The effect of different White Balance settings

› BKT

Bracketing means taking a series of shots where one key setting is varied. For instance, if it's tricky to determine the correct white balance, then white balance bracketing gives you several variations, from which you can choose the best later. The BKT section of the Quick Menu allows you to choose the number of shots in a bracketed sequence (three or five) and the magnitude of the difference ("increment") between them.

You can also bracket exposure, by varying either ISO sensitivity (Sv) or shutter speed (Tv). The Range control allows you to vary exposures equally either side of the camera's suggested exposure, or to bias the variation more towards under- or overexposure (*see page 86*).

> **Note:**
> White balance bracketing is not available when Image quality is set to NRW (RAW).

My Menu is a way to give speedier access, through the Quick Menu, to five selected items from the other menus. You can select which items will be displayed here using **Customize My Menu** in the Setup Menu (*see page 126*).

✏ Nikon Picture Controls

Nikon Picture Controls influence how JPEG images are processed by the camera, specifically affecting contrast, sharpening and color saturation. The P7700 offers four preset Picture Controls: **Neutral**, **Vivid**, and **Monochrome** are all fairly self-explanatory. **Standard** gives a compromise setting which works reasonably well in a wide range of situations.

You can fine-tune the settings for each of the preset Controls, and you can also create and save your own Custom Picture Controls, though this requires a visit to the Shooting menu (*see page 97*) or My Menu (*see above*).

POST BOX ⩢
Vivid and Neutral Picture Controls applied to the same subject. *ISO 300, 28mm, 1/50 sec., f/8.*

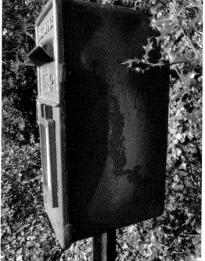
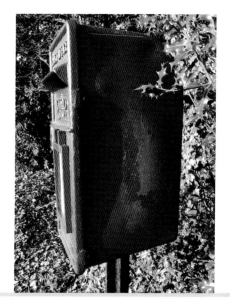

Modifying Picture Controls

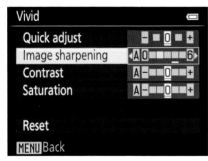

Nikon Picture Controls can be modified in-camera. Use **Quick Adjust** to make swift, across-the-board changes, or adjust the parameters individually (**Sharpening**, **Contrast**, **Saturation**).

1) Select ⚏ **Picture Control** in the Quick Menu, then use the Multi-selector to highlight the required Picture Control. Press ▶.

2) Scroll up or down with the Multi-selector to select **Quick Adjust** or one of the specific parameters. Use ▶ or ◀ to change the value as desired.

3) When all parameters are as required, press **OK**. The modified values are retained until that Picture Control is modified again.

Creating Custom Picture Controls

1) From the Shooting menu, select **Custom Picture Control**.

2) Select **Edit** and save and press ▶.

3) Use the Multi-selector to highlight an existing Picture Control and press **OK**.

4) Modify the Picture Control (see above). When all parameters are as required, press **OK**.

5) On the next screen, choose whether to save the new Picture Control as **Custom 1** or **Custom 2**. If you've already saved a Custom 1 Picture Control, selecting **Custom 1** again here will replace it with the new one.

6) Press **OK** to store the new Picture Control.

You can also delete Custom Picture Controls (but not the four standard ones).

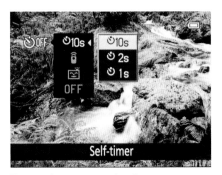

Timer and remote control options on screen

The P7700 doesn't limit you to taking a single picture by pressing the shutter-release button; there are several other options. First you can opt to shoot a continuous burst of images. Options for this are found in the Shooting menu (and also in My Menu).

The usual setting is ⑤ Single, where the camera takes a single shot each time the shutter release is fully depressed.

You can also opt for: 🖵 Continuous H; 🖵 Continuous M; or 🖵 Continuous L. Here the camera fires continuously while the shutter release is fully depressed. The maximum frame rate is 8 frames per second (fps) in 🖵, 4fps in 🖵 and about 1fps in 🖵. The number of shots the camera can capture in a continuous burst like this is limited to 6 in 🖵 and 🖵, up to 30 in 🖵.

If you're shooting RAW images the camera can still capture 6 in a burst, but after shooting them, there's then a delay of up to 30 seconds while the camera catches up with writing all of these images to the memory card. This can be very frustrating, and may well lead to missing an even better shot. With JPEG images, the delay is still there but it's normally only 2 or 3 seconds.

There are some other, more obscure continuous shooting options (*see page 97*).

The P7700 can also be triggered using its self-timer or with Nikon's ML-L3 remote (*see page 213*). To access these options, press ⟳ on the Multi-selector; in ⟳ **Self-timer** and 🖥 **Remote control**, press ▶ for further options. Press **OK** to select.

› ⟳ Self-timer

When you press the shutter-release button, there is a pre-determined delay before the shutter is released. It's usually used for self-portraits and to include yourself in group shots, but when shooting on a tripod or other support it can also help to reduce vibration which can blur your pictures. A 10-second interval is usually better for getting yourself into shot, but 2 seconds is plenty for reducing vibration.

› Remote control

This requires the ML-L3 remote control (*see page 213*). Again it can reduce vibration or allow you to include yourself in shot. Sub-options let you fire the shutter immediately upon tripping the remote, or select delays of 1, 2, or 10 seconds.

› Smile timer

This mode uses an extension of Face Detection technology to detect when someone has smiled and to take the shot at that moment. Having selected this option, press **OK**; the camera looks for faces. If it finds more than one, it will focus on the one nearest the center of the frame. When that face smiles, the camera will take a shot. (If you press the shutter-release button, the camera shoots immediately.)

Smile timer remains active for further shots, until you press ✆ again and change the setting.

STRIDING OUT »
With no-one else around, the self-timer was handy for this "action" shot for a walking guidebook. *ISO 400, 70mm, 1/500 sec., f/8.*

Choosing a Shooting mode from the Mode Dial can make a big difference to the way the picture will look, and the amount of control you can—or can't—exercise. The P7700's Shooting modes fall into three main groups: Auto, Scene modes, and User-control modes. There's also an EFFECTS position on the Mode Dial for more extreme or wacky results.

In Auto and Scene modes, most settings are controlled by the camera. Auto uses all-purpose, compromise settings, while Scene modes are tailored to particular situations. User-control modes give you complete control over nearly every setting.

› ◘ Auto mode

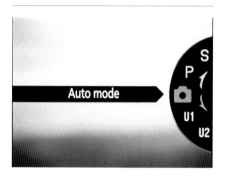

Auto is a one-size-fits-all shooting mode. You'll hardly ever get a shot that doesn't "come out" at all, but you may find that the results aren't always exactly what you were aiming for; it's the camera, not you, that's deciding what kind of picture you are taking and how it should look.

For example, the camera always chooses where to focus. You can change to Manual Focus, Close-up or Infinity, but you can't shift the focus point. If your main subject is off-center, the only way to make the camera focus there is by using focus lock (*see page 81*). Exposure is fully automatic, although you can modify it using the Exposure Compensation Dial.

QUICK SHOOTING «
Auto mode is ideal when shots need to be grabbed quickly, but can inhibit control and creativity. *ISO 400, 200mm, 1/400 sec., f/8.*

Mode group	Position on Mode Dial	Exposure mode	Comment	Flash
Auto	📷	Auto	Leaves all decisions about settings to the camera.	Optional
User-control modes	P S A M	Program Shutter-priority Aperture-priority Manual	Allow much greater control over the full range of camera settings.	Optional
Movie	🎥	Movie mode	For simple shooting of movie clips.	Not available
Movie Custom Setting	🎥 CSM	Movie mode	Shoot movie clips with more control options.	Not available
Scene Modes	SCENE (Use Menu to select specific mode)	Portrait	Choose the appropriate mode to suit the subject and the camera then employs appropriate settings.	Optional
		Landscape		Not available
		Sports		Not available
		Night portrait		Compulsory
		Party/indoor		Optional
		Beach		Optional
		Snow		Optional
		Sunset		Not available
		Dusk/dawn		Not available
		Night landscape		Not available
		Close up		Optional
		Food		Not available
		Museum		Not available
		Fireworks show		Not available
		Black and white copy		Not available
		Backlighting		Optional (not available in HDR sub-mode)
		Panorama		Optional
		Pet portrait		Not available

Mode Group	Position on Mode Dial	Exposure mode		Flash	Comment
Special Effects	EFFECTS (Use Menu to select specific mode)	🎞	Creative monochrome	Use for more extreme pictorial effects.	Optional
		🖼	Painting		Not available
		🔲	Zoom exposure		Not available
		◎	Defocus during exposure		Optional
		🎨	Cross process		Optional
		SOFT	Soft		Optional
		SEPIA	Nostalgic sepia		Optional
		HI	High key		Optional
		LO	Low key		Optional
		🖊	Selective Color		Optional
User Settings	U1, U2, U3	Variable		Flexible user-defined settings.	Optional

› Scene modes

The 19 Scene modes (some of which have a couple of sub-modes) are designed to set the camera appropriately for a range of situations. Even experienced photographers can find them handy when time is short, while newcomers will find them an ideal way to discover how differently the camera can interpret the same scene. This makes them a great stepping-stone to the wider range of options offered by the P7700.

Selecting Scene modes

1) Set the Mode Dial to **SCENE**

2) Press **MENU**. The top tab is now labelled SCENE. Use the Multi-selector to navigate through the list of Scene modes.

3) Highlight the required mode and press **OK**. In a few cases there are extra options, indicated by an icon in the right-hand column. Press ▶ to access these.

4) If you rotate the Mode Dial away from **SCENE** (e.g. to shoot a movie clip) and then return it to the **SCENE** position, the camera recalls the last-used Scene mode.

› 🎭 Scene auto selector

Here the camera analyzes the scene and selects what seems to be the most appropriate Scene mode. This can be handy if you're shooting a variety of subjects under rapidly changing conditions, but it's both more rewarding and often more accurate to make your own selection.

› 🂱 Portrait

In Portrait mode the camera sets a relatively wide aperture to reduce depth of field (*see page 144*), helping subjects stand out from their background. The camera also selects the focus point automatically using Face Detection technology. The flash is available; it defaults to Red-eye reduction mode (*see page 174*), which causes a delay between pressing the shutter and capturing the image, but you can change this. The camera processes the image using a Portrait Picture Control and

applies Skin softening (*see page 135*). However, if you'd prefer to break with convention and go for a grittier, sharper, or more vivid style of portrait, it's better to choose Aperture-priority—in which case you can also shoot RAW.

> ### Tip
>
> *Scene modes only shoot JPEG, not RAW, so the White Balance, Picture Control, and so on are fixed in the file.*

HEAD SHOT ☄
Portrait mode. *ISO 200, 105mm, 1/640 sec., f/3.5.*

> ### Tip
>
> The focal lengths traditionally considered best for portraits are in the short telephoto range: at 85mm the P7700's widest aperture is f/3.2 and at 105mm it's f/3.5. These settings for a head-and-shoulders portrait will soften backgrounds quite effectively.

Traditional landscape photographers usually aspire to get everything in the scene in focus; in other words, they seek to maximize depth of field (*see page 144*). The P7700's Landscape mode does not do

this; it often sets the lens to its widest aperture, and invariably sets the focus to Infinity. When you frame an image that includes close foreground detail, this may not always be recorded sharply. There's nothing you can do to remedy this except exit Landscape mode and choose one of the User-control modes instead. (Perhaps we should call this "Distant Views" mode?)

Image processing is intended to give vibrant colors, though results often look a little cool to me. Flash is not available, even in low light. If you want to use fill-in flash to brighten a dark foreground (*see page 173*), the remedy once again is to select a User-control mode.

Tip

If you shoot landscapes a lot and want to get around the issue of foregrounds not being sharp, you can employ User settings (see page 90) to create a "bespoke" Landscape mode. For me key settings here include aperture f/5.6 or f/8 and AF-area mode to Manual. I also shoot RAW, and apply whatever sharpening and color-boosting may be necessary in Lightroom, but if you shoot JPEG you could apply a Vivid or Custom Picture Control.

AUTUMN COLORS ❯❯
This mode aims to keep more distant subjects sharp, and give vibrant colors. *ISO 200, 75mm, 1/400 sec., f/2.8.*

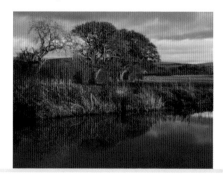

> ⚡ Sports

Sports mode is intended for shooting not just sports but other fast-moving subjects, including wildlife. The camera will shoot continuously at 8fps if you keep the shutter-release button pressed, but can't usually manage more than six images in one burst, assuming Image quality is set to Normal. It will also set a fast shutter speed to freeze the action. This implies a wide aperture, though you'll often be using the 200mm end of the lens range, where f/4 is the widest available.

In Autofocus operation, the camera focuses at the center of the frame, which may well not be what you want for tight action shots. However, unusually among Scene modes, you can select Manual focus instead. This allows you to prefocus on a selected point; once you've done this you know there won't be any annoying (and shot-missing) delays while the camera tries to refocus. Prefocusing works best if

you look for a specific point or moment where the action should be spectacular, like the finishing line, an obstacle, or a tight bend.

While 8fps is a very fast shooting rate, beating some of Nikon's DSLRs, firing away continuously (and therefore semi-randomly) it isn't a guarantee of great results. And after you've shot a burst of six frames, there's a delay of a few seconds (longer if you're shooting RAW) while the camera writes these to the memory card. During this delay you could be missing an even better shot. If you shoot single frames the camera will be ready to shoot again much sooner.

RAPID SHOOTING ⌄
A high shutter speed "freezes" the white-water as well as the kayaker. *ISO 400, 165mm, 1/1000 sec., f/4.*

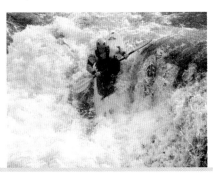

Scene menu

- ▦ Scene auto selector
- ▨ Portrait
- ▤ Landscape
- ⚡ Sports
- ◪ Night portrait
- ✹ Party/indoor
- ☂ Beach

In most respects Night portrait mode is similar to regular Portrait mode, but when the ambient light is low the camera sets a long shutter speed to record an image of the background, while using the flash to illuminate the foreground subject. The flash operates in red-eye reduction mode (see page 174). If you don't raise the flash, the camera just continues to display the

"Raise the flash" message, and refuses to take a shot.

The camera uses Face Detection focusing; if it fails to detect any faces it will focus at the center of the frame. Image processing is similar to regular Portrait mode, with Skin softening (see page 135) being applied.

In Night portrait mode, lengthy exposure times are possible and it's therefore advisable to use a tripod or other solid camera support to avoid camera-shake. It's recommended to turn Vibration Reduction Off when using a tripod: this requires a brief visit to the Setup menu.

In this mode, you can't use the digital zoom. The logic for this is probably that using digital zoom for a portrait subject would mean that he or she is beyond the range of the flash.

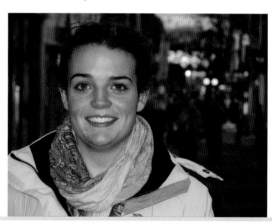

NIGHT LIFE »
The camera has balanced flash and background pretty well here. *ISO 400, 200mm, 1/30 sec., f/4.*

› ✿ Party/indoor

Scene menu
- ▦ Scene auto selector
- ✍ Portrait
- ▥ Landscape
- 🏃 Sports
- 🌃 Night portrait
- ✿ Party/indoor
- 🏖 Beach

Party/indoor mode is similar to Night portrait in seeking to record both people and their background, but does not allow such long exposures to be set. This time, however, the camera will allow you to shoot without flash. If you do raise the flash, red-eye reduction flash is again the default, with the usual inevitable delay; this is not ideal for "spontaneous" shots. Fortunately, you can change the flash mode.

Although exposure times aren't as long as they can be in Night Portrait, they can still be long enough to make steady shots unlikely when handholding. If you are handholding the camera, as you may well be in a party setting, make sure Vibration Reduction is **On**. You may also find it helpful to brace yourself against a handy object such as a table, chair, or wall. If you are using a tripod or other really solid camera support, it's better recommended to turn Vibration Reduction **Off** in the Setup menu.

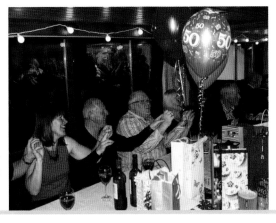

PARTY TIME　　　　》
Again, flash and background lighting are fairly well-balanced here. *ISO 800, 28mm, 1/13 sec., f/2.*

Scene menu
- 🎬 Scene auto selector
- Portrait
- Landscape
- Sports
- Night portrait
- Party/indoor
- Beach

Beach and snow scenes are notorious for disappointing results—the subject is full of bright tones and yet pictures all too often turn out relatively dark. This is usually because camera metering systems tend to assume they're looking at an average subject, and to try and make the results look average too.

Beach mode allows for this, partly by applying exposure compensation (*see page 84*) and partly through image processing.

The camera focuses at the center of the frame, and your only focus options are regular AF and 🌷 Macro close-up. If you want to focus accurately on an off-center subject, you can use focus lock (*see page 81*).

The flash is available; you might wonder why you'd need it in bright conditions, but it can be very useful to fill in dark shadows (e.g. someone's face under a sunhat). Of course if the face is your main subject you might choose Portrait mode instead, but if the person is a relatively small part of the scene they could easily look too dark without the help of fill-in flash.

ON THE BEACH »
This mode preserves overall lightness. *ISO 100, 85mm, 1/1000 sec., f/3.2.*

> ⌷ Snow

Scene menu
- ⌷ Snow
- Sunset
- Dusk/dawn
- Night landscape
- Close-up
- Food
- Museum

Even more than beach shots, snow scenes can suffer from the tendency of cameras to produce an "average" image when the subject was far from average. A typical result is snow that looks gray, because gray, not white, is the average tone. This is counteracted mainly by using exposure compensation (*see page 84*), and the main

difference between this and the previous mode is that in ⌷ Snow mode the amount of compensation applied is even higher.

Other than this, there's no difference between the two modes that you'll readily notice during actual picture-taking. Once again, the camera focuses at the center of the frame and the flash is available.

This mode won't necessarily be ideal for every winter shot as not every scene is dominated by expanses of snow. Mountain views may contain as much dark rock as snow, for example. It's a good idea to check that results look right, and if necessary either switch to another mode such as ◤ Landscape, or manually apply some exposure compensation.

Tip

The very bright conditions on sunny beaches and snowy scenes can make it particularly hard to see the screen clearly, making it difficult either to frame your shots or to assess them properly on playback. If you don't have a screen-shade (see page 214) you might need to improvize, e.g. by hiding under a beach-towel.

WHITE-OUT ⌄
This mode preserves overall lightness. *ISO 100, 85mm, 1/1600 sec., f/3.2.*

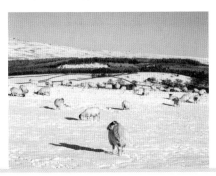

Sunset mode is broadly similar to Night landscape. The camera sets Infinity focus, the flash is not available, long exposure times are possible and a tripod is recommended. Unlike Night landscape, white balance and image processing are adjusted with the main aim of preserving the vivid tones of sunset skies. (It works well for vivid sunrises too!)

Dusk/dawn mode is again quite similar, but allows for the more muted colors and lower contrast usually experienced before sunrise and after sunset; think of it as a mode suitable for shooting the wider landscape at these times, while Sunset is focused specifically on lurid skies. Again, flash remains off and a tripod is recommended.

VIVID SKY ☒
Sunset mode is all about vivid skies. *ISO 100, 45mm, 1/125 sec., f/3.2.*

MUTED LANDSCAPE ☒
This mode suits the softer light of dusk and dawn. *ISO 400, 70mm, 1/80 sec., f/3.2.*

› 🖼 Night landscape

Night landscape mode is designed to be used after dusk and before dawn. However, it's more likely to be effective in capturing city lights at night than in the deeper darkness of a rural setting, even under a

NIGHT REFLECTIONS ⌄
Tripod mode didn't do a bad job here; the result was noticeably sharper than a comparison shot taken in Handheld mode. Personally I find the result from Auto White Balance rather cold, though. Compare the version *on page 76. ISO 80, 28mm, 2 sec. (tripod), f/2.*

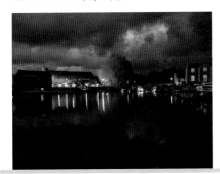

full moon. Again, focus is set to Infinity and the flash is not available. Images are processed to reduce noise and preserve colors, including the varied colors of artificial light. There are two sub-modes, 🖐 Handheld (the default) and 🖥 Tripod.

› 🖐 Handheld

The camera shoots a series of images and then combines them, "adding" the light from each individual frame. Shutter speeds are relatively high to keep individual images sharp, and the camera aligns them during the combination process to allow for any movement of the camera. It's still a good idea to keep the camera as still as you can. Don't switch off until processing is complete or the shot may be lost.

› 🖥 Tripod

Tripod mode is closer to a traditional photographer's approach to night-time landscapes. The ISO setting is fixed at 80 to reduce noise and maximize dynamic range (*see page 156*). This naturally means that exposure times are often lengthy. As a result, Noise reduction is often applied, which can cause a few seconds' delay before you can take another shot. The camera focuses at Infinity. Vibration reduction is cancelled automatically.

Close-up and food modes are very similar in most respects. The camera sets 🌺 macro close-up focus. Unusually for scene modes, the focus point can be adjusted manually: press **OK**, then move the focus point using the Multi-selector. This is handy, as there's little room for error at close range.

Although depth of field is reduced at close distances, the camera still sets a fairly wide aperture. This is presumably intended to keep shutter speeds up.

In 🌺 Close-up the flash is available; pop it up and you can then select from the full range of flash modes. However, it must be remembered that the built-in flash doesn't do a great job on close-ups, and at really close range will only light part of the subject. *See page 190* for more on this, and some alternative ways to light a macro subject.

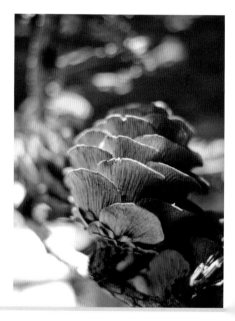

CLOSE-UP CONE »
Depth of field is minimal and the focus point clearly was not the center of the frame. *ISO 80, 28mm, 1/80 sec., f/2.*

› ¶¶ Food

In many ways, Food mode is similar to 🌷 Close-up—you can shift the focus point in the same way. However, there's a key difference: the flash is always off—you can pop it up but it won't fire. This makes Food mode a possible choice for other close subjects when you don't want to use flash.

¶¶ Food also offers a unique "hue selector", visible on the left of the screen. The wide variety of restaurant lighting, and the range of colors in different foods, make Auto White Balance unreliable, and the hue selector gives a degree of compensation. Scroll up or down using the Multi-selector; the screen gives a rough preview of the results. This could come in handy for other indoor shots when Auto White Balance doesn't seem to do the trick.

For much more about close-up and macro shooting, see Chapter 5, *page 184*.

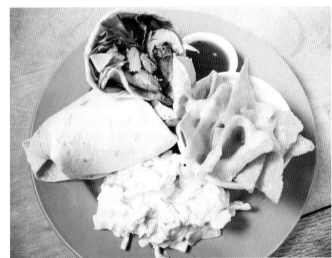

PLATE-FULL »
Food mode has quick color adjustment.
ISO 125, 28mm, 1/30 sec., f/2.

2 › 🏛 Museum

museums. As well as turning off the flash, the camera also deactivates the AF-assist illuminator. Because available light levels may be low, the risk of camera-shake increases. One way of combating this is to keep the shutter-release button depressed; the camera then captures up to 10 images and uses Best Shot Selector (*see page 98*) to pick the sharpest.

🏛 Museum is designed for settings where flash is banned or inappropriate—there are many of these apart from

The camera always focuses at the center of the frame, but you can switch between normal autofocus and 🌷 Macro close-up.

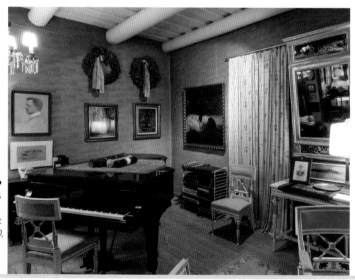

MUSEUM »
Museum mode is useful when you can't or shouldn't use flash. *ISO 800, 28mm, 1/5 sec., f/2.*

› ⚙ Fireworks show

Scene menu

⚙	Fireworks show
🖵	Black and white copy
🎇	Backlighting — OFF
🖵	Panorama
🐕	Pet portrait
3D	3D photography

⚙ Fireworks show sets infinity focus and the flash is unavailable; these are sensible measures. Unfortunately, however, shutter speed is fixed at 4 seconds, which is far too short to make a really spectacular record of large fireworks displays. It's hard to see the logic of this; 4 seconds is way too long an exposure for handholding, so you'll have to use a tripod anyway. Of all the Scene modes, this is possibly the least suitable for its intended purpose.

Fortunately, there is an alternative: after wide experience of shooting fireworks, I will only ever use Manual mode. I set the ISO to 80, shutter speed to 30 seconds, and aperture to f/8. (On my DSLRs I'll use even longer exposures and smaller apertures.) Although I use a solid tripod, I try to reduce vibration still further, using the ML-L3 remote (*see page 213*) to trigger the shutter.

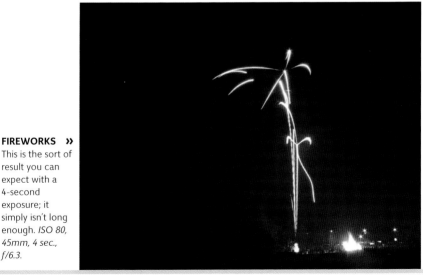

FIREWORKS »
This is the sort of result you can expect with a 4-second exposure; it simply isn't long enough. *ISO 80, 45mm, 4 sec., f/6.3.*

🔲 Black and white copy produces monochrome copies of print or drawings on a white background. Focus is at the center of the frame and flash is off, so make sure lighting is good.

When shooting at close range, you can use 🌷 Macro close-up focusing. However, if you're too close to the subject, you'll find it harder to light it evenly, as you and/or the camera will often create shadows. It's often better to move back and use a longer focal length setting. At the 200mm zoom setting, using 🌷 Macro close-up, the closest focusing distance is about 16in.

Tip

Remember that copying other people's writings or artworks without permission infringes copyright.

(40cm). This still allows you to copy a fairly small area—less than a quarter of an A4 page.

Using the 200mm setting has other advantages, as there's less distortion than at 28mm, and it's easier to ensure that you're shooting perpendicular to the subject. Both factors help give better-looking results, especially on subjects which contain lines of text or other straight lines. If your subject is large enough, you'll get even better results at a zoom setting around 105–135mm.

IN BLACK AND WHITE ⌄

At 200mm, straight lines are very slightly bowed inwards.

› 🎐 Backlighting

This is one of the more complex Scene modes. In fact, it's helpful to think of it as two sub-modes. When you select 🎐 Backlighting in the Scene menu, you can press ▶ to select either **OFF** or **HDR**. Press **OK** to continue.

OFF

Use this sub-mode when shooting portraits or other nearby subjects against a much brighter background, which can turn the subject into a silhouette. The camera prompts you to raise the flash, which provides "fill-in" light to improve the balance between subject and background.

HDR HDR

Use this sub-mode to shoot landscapes or more distant subjects where there's a very wide range of brightness. The flash is no use on distant subjects and the camera takes a different approach. Listen closely

and you can hear the shutter operate several times. The camera actually records three images. One is a fairly normal image, but processed using D-Lighting (*see page 134*) to boost the shadows. The other two are combined to create an HDR composite image. One exposure will be relatively brief to capture as much highlight detail as possible, while the other will be longer to favor the shadows. It's a very good idea to use a tripod or other solid support to keep the two images perfectly aligned. The camera takes a few seconds to combine the two.

There are three levels of HDR, depending on just how great the brightness range is. It pays to experiment.

OUT OF THE SHADOWS ⌄
HDR mode has done a reasonable job of capturing detail in both shadows and highlights, in very challenging conditions, but the end result has poor color saturation. *ISO 80, 28mm, 1/1250 sec., f/2.*

2) Select Normal (180°) or Wide (360°) and press **OK**.

3) As per on-screen instructions, press the shutter release then pan steadily, vertically or horizontally.

The P7700's 28mm-equivalent lens often isn't wide enough to capture the full sweep of a big landscape or city view. One solution is to shoot several overlapping images which are then merged into one. The P7700 can do this in-camera (⊟ Easy panorama) or you can do it on the computer later. ⊞ Panorama assist helps you to align source images at the shooting stage. A tripod is recommended.

Using ⊟ Easy panorama

1) Select ⊟ Easy panorama and press ▶.

Using ⊞ Panorama assist

1) Select ⊞ Panorama assist and press **OK**.

2) Use the Multi-selector to select the direction in which you'll scan the scene after the first image (shown by yellow arrows), then press **OK**.

3) Take the first shot. After recording, a "ghost" image of part of this frame appears on the screen. Use this to help line up the next shot; the ghost image disappears when the overlapping areas are lined up perfectly.

4) Take further shots in the same way. When the sequence is complete, press **OK**.

SWEEP ❱❱
A panorama created using Easy panorama.

› 🐾 Pet portrait

Pet portrait
- ⬚ Single
- ⬚ Continuous

Recommended for portraits of active pets, and specifically dogs and cats. You can select Single or Continuous mode for this—press ▶ while in the Scene menu (Continuous is the default setting).

By default, the camera employs a special focus mode—Pet Portrait auto release. This uses a specialized form of Face Detection to identify dogs or cats (it is not designed to work on other species, but may be worth a try, at least with other mammals). When a subject is detected and the camera can focus on it, the shutter will fire automatically—once if Single is selected, three times if Continuous is in effect, at about 1fps.

Pet Portrait auto release can be turned off: press ◀ and select **OFF** from the pop-up menu that appears. When it's off, or if no pet faces can be detected, the camera will focus at the center of the frame, in the normal way, when you press the shutter-release button halfway.

The AF-assist illuminator is always off.

SHEEP　　　　》
The Nikon manual specifies that Pet portrait mode is for shooting cats and dogs, but it seems to work for some other creatures too. *ISO 80, 200mm, 1/1250 sec., f/4.*

Scene menu

🎆 Fireworks show
📄 Black and white copy
📷 Backlighting OFF
🗔 Panorama 🎞
🐾 Pet portrait 🆂
3D 3D photography

Like 3D cinema, 3D imaging divides opinion, and has so far failed to take the world by storm. The fact that you need special equipment to view 3D images—usually a 3D TV set and special glasses—is a clear limitation. Still, for those who are interested, the P7700 can record 3D images.

File size is fixed at **2m** (1920 x 1080 pixels), which is appropriate for HD (3D) TV sets. The process only works for static subjects, and is most effective with subjects reasonably close to the camera. The final 3D image will be less wide than the preview on the monitor because only the areas which overlap in both images will be recorded.

To record a 3D image

1) Select **3D** Photography and press **OK**.

2) Frame the first shot. Zoom setting, exposure, white balance and so on will be maintained for the second image.

3) Press the shutter-release button to take the first shot. Move the camera to the right to align the guide image with the subject. When they line up satisfactorily, the camera will take the second shot automatically. If they fail to line up within 10 seconds, the process will be cancelled.

4) A duplicate of the first image will be saved as a JPEG file.

BREAKING DOWN WALLS **»**
Potentially an excellent subject for a 3D image.

» SPECIAL EFFECTS MODES

Special Effects modes are designed to produce radical image effects. Most of them are like extreme Picture Controls: they process JPEG images to produce various striking effects, and most cannot be used to shoot RAW images. However, a couple of the modes also affect the physical operation of the camera.

To use Special effects modes:

1) Set the Mode Dial to **EFFECTS**. Press **MENU**.

2) The uppermost Menu tab becomes an 🖋 Effects tab. Press ▶.

3) Select Special effects and press ▶ again.

4) Highlight the required mode and press **OK**.

The following effects are available.

› 🖋 Creative monochrome

Mimics traditional black-and-white film photography. Vary the amount of grain by rotating the Main Command Dial; vary the level of contrast or choose a solarized effect by rotating the Sub-command Dial. The screen shows a preview of the result.

OLD BOAT »
A high-contrast treatment in 🖋 Creative monochrome. For alternative views of the same subject *see page 173.*

› ⊟ Painting

› ▨ Zoom exposure

Allegedly, this creates "images with the ambience of paintings". As there are no subsidiary options, only one very specific style of painting is possible, and it's certainly not to everyone's taste. The screen shows a preview of the result.

You can also apply this as an "after effect" to an existing image (*see page 136*).

During a 2-second exposure, the camera zooms in from a wide to telephoto setting, creating a dynamic streaking effect. If the light is too bright to make such a long exposure possible, shots can still be taken but no zoom effect will apply. If a sufficiently long exposure is possible, the ▨ icon will turn green.

Because it requires the lens to zoom during the shot, the monitor cannot preview the effect.

▨ Zoom exposure can be used to shoot NRW (RAW) images.

› ◎ Defocus during exposure

The camera focuses normally, but then makes a shift in focus during the exposure. This produces a sharp image combined with a slight glow or halo, which is most prominent around bright areas and highlights. As this requires time, the effect can only work with a relatively slow shutter speed, though nowhere near as long as the 2 sec. for the previous mode; the limit appears to be 1/15 sec. If such an exposure is possible, the ◎ icon will turn green.

Because of the focus shift required, the monitor cannot preview the effect.

◎ Defocus during exposure can be used to shoot NRW (RAW) images.

› ✂ Cross process

This mode roughly imitates unusual processing techniques from film photography, producing a range of color effects. Vary the color balance by rotating the Main Command Dial.

It should be said that true cross-processing could produce very distinct results, with colors often shifting one way in the highlights and another in the shadows. ✂ Cross process mode does not really replicate this; disappointingly, it just produces an overall color shift, rather similar to using a colored filter or a "wrong" White Balance setting.

› SOFT

Adds a subtle overall softening effect. It is stronger than that applied by the Skin softening effect in, for example, ⚡ Portrait mode, but doesn't match the real "glow" which can be achieved in ◎ Defocus during exposure.

You can also apply softening as an "after-effect" to an existing image (*see page 136*).

› SEPIA Nostalgic sepia

TINT OF NOSTALGIA ⌃
Matching Nostalgic sepia with a heritage subject creates an image which could have been taken decades ago. *ISO 800, 28mm, 1/20 sec., f/8.*

Mimics the brownish sepia tone and reduced contrast often seen in antique photos. There are no options to control the effect.

› HI High key

Produces images filled with light tones, usually with no blacks or deep tones at all. It's not clear, in practical terms, whether this mode does anything more than simple overexposure.

› LO Low key

Low key is basically the opposite, creating a deep, low-toned image. Again, it's not clear whether this mode does anything more than simply underexpose the image.

› 🖊 Selective color

This enables you to isolate a specific color, and reduce the rest of the image to monochrome.

1) Press **OK**. This brings up a palette on the left of the screen.

2) Move up and down the palette using ▲ /▼. The screen gives a preview of the result. When it's what you want, press **OK**.

3) Adjust framing, zoom, etc. if necessary and take the shot.

IN THE RED ⌄
Selective color usually looks best when there are fairly obvious blocks of a specific color for it to pick up on.

» USER-CONTROL MODES

The final four modes are traditional standards, which will be familiar to any experienced photographer. As well as allowing direct control over the basic settings of aperture and/or shutter speed (even in P mode through flexible program), these modes give full access to controls like White Balance (*see page 37*) and Nikon Picture Controls (*see page 40*), both of which are in the Quick Menu, as well as Active D-Lighting (*see page 101*); this resides in the Shooting menu and you can also add it to My Menu. Between them, these controls give you great freedom to decide how you want the image to look and feel.

› (P) Program

In **P** mode the camera sets a combination of shutter speed and aperture that will give correctly exposed results in most situations. Of course, the same is true of Auto and Scene modes, but P mode gives you a much closer involvement with what the camera's doing. It allows you to adjust other parameters to suit your own creative ideas, including White Balance (*see page 37*), Active D-Lighting (*see page 101*) and Nikon Picture Controls (*see page 40*). It also allows manual selection of ISO rating (*see page 88*).

You can have even more control over the results through options like flexible program (see next page), exposure lock (*see page 85*), and exposure bracketing (*see page 86*).

ABBEY HABIT **«**
This mode allows you to tailor camera settings to suit your own creative ideas. *ISO 200, 35mm, 1/500 sec., f/8.*

Using Program mode

1) Rotate the Mode Dial to position **P**.

2) Frame the picture.

3) Half-depress the release button to activate focusing and exposure. The focus point(s) are displayed on the LCD screen (depending on the AF-area mode in use). Shutter speed and aperture settings appear at the bottom of the screen.

4) Fully depress the shutter release to take the picture.

Flexible program

Without leaving P mode you can change the combination of shutter speed and aperture by rotating the Main Command Dial; the readouts at the bottom of the screen can be seen to change. While flexible program is in effect the P indication in the Information display changes to **P***.

Flexible program does not change the overall exposure. As shutter speed increases, the aperture gets wider, and vice versa. However, it does allow you to shift quickly to a faster shutter speed to freeze action, or a smaller aperture to increase depth of field (*see page 144*), giving much of the control that S or A modes offer.

The Flexible Program indicator

› (S) Shutter-priority

Shutter-priority auto

In Shutter-priority (**S**) mode, you control the shutter speed while the camera sets an appropriate aperture to give correctly exposed results in most situations. Control of shutter speed is key for moving subjects (*see page 149*). The fastest shutter speed that can be set is 1/4000 second; the slowest available speed depends on the ISO setting. For instance, at ISO 80 or 100 you can set it as low as 15 seconds. At ISO 200 the lowest setting is 8 seconds, and so on. The only way to set even longer shutter speeds (down to 60 seconds) is to use Manual mode.

Fine-tuning of exposure is possible through exposure lock (*see page 85*), exposure compensation (*see page 84*), and possibly auto bracketing (*see page 86*).

Using S mode

1) Rotate the Mode Dial to position **S**.

2) Frame the picture.

3) Half-depress the release button to activate focusing and exposure. Shutter speed and aperture settings appear at the bottom of the LCD screen. Rotate the Main Command Dial to alter the shutter speed; the aperture will adjust automatically.

4) Fully depress the shutter-release button to take the picture.

Tip

In any User-control mode, it is often helpful—time permitting—to review the image after taking the shot (a process now known as "chimping"). This can reveal, for example, how movement has been recorded at your selected shutter speed. The histogram display (see page 87) also gives an accurate check on overall exposure. If necessary you can then make further adjustments to refine your results.

Scene modes and shutter speed

Sports mode, in particular, aims to set a fast shutter speed. This is fine up to a point, but does not give the direct and exact control that S mode does. S mode also allows quick shifts to a much slower shutter speed, which can be a great way to get a more impressionistic view of action. *See page 149* for more about shutter speeds.

SMOOTH WATER ❯❯
A slow shutter speed smoothed the flowing water.
ISO 80, 50mm, 1 sec. (tripod), f/8 + Built-in ND filter (see page 100).

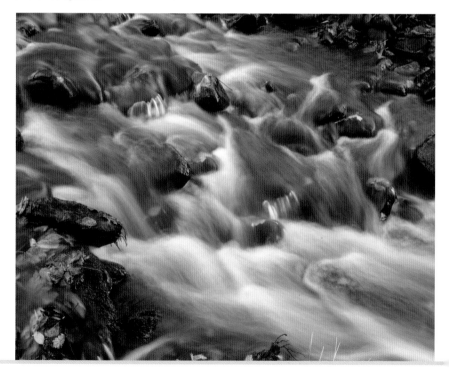

› (A) Aperture-priority

Aperture-priority auto

In Aperture-priority (**A**) mode, you control the aperture while the camera sets an appropriate shutter speed to give correctly exposed results in most situations. Control of aperture is particularly useful for regulating depth of field (*see page 144*). The range of apertures available is limited by the lens that's fitted, not by the camera.

As usual, fine-tuning of exposure is possible through exposure lock (*see page 85*), exposure compensation (*see page 84*), and possibly auto bracketing (*see page 86*).

The range of apertures available is determined by the zoom position of the lens; at 28mm aperture can be set between f/2 and f/8 while at 200mm the range is from f/4 to f/8. There's no escaping the fact that Aperture-priority on the P7700

(or any compact camera) is less versatile than on a DSLR because there's a smaller range of apertures to choose from.

Using A mode

1) Rotate the Mode Dial to position **A**.

2) Frame the picture.

3) Half-depress the release button to activate focusing and exposure. Shutter speed and aperture settings appear at the bottom of the LCD screen. Rotate the Main Command Dial to alter the aperture; the shutter speed will adjust automatically.

4) Fully depress the shutter-release button to take the picture.

MOUNTAIN VIEW »
This mode helps you control depth of field. *ISO 200, 28mm, 1/200 sec., f/8.*

Manual

In **M** mode, you control both shutter speed and aperture for maximum creative flexibility. If you're new to using manual, try it first when shooting without pressure of time, or in fairly constant light conditions. Some experienced photographers use it habitually, enjoying the feeling of complete control.

Shutter speeds can be set to any value between 60 seconds (see below) and

1/4000 second. The range of apertures available is determined by the zoom position of the lens, as in mode A.

Using M mode

1) Rotate the Mode Dial to position **M**.

2) Frame the picture.

3) Half-depress the release button to activate focusing and exposure. Shutter speed and aperture settings appear at the bottom of the LCD screen. Below them is an analog exposure display; refer to this and if necessary adjust shutter speed, aperture, or both, to achieve correct exposure.

4) Rotate the Main Command Dial to alter the shutter speed.

5) Rotate the Sub-command Dial to alter the aperture.

6) Fully depress the shutter-release button to take the picture.

Note:
The maximum 60 seconds shutter speed is only available when the ISO rating is 400 or lower. At ISO 800, the limit is 30 seconds, at ISO 1600 it's 15 seconds, and at ISO 3200 it's just 8 seconds. It's likely that these limits mark the point beyond which image noise (*see page 162*) would simply be excessive.

SAILS TARGET »
This was a tricky subject. Overall the scene is fairly dark, but it was important not to lose detail in the white sails and hull of the boat; I used manual mode and "chimped" the histogram and highlights displays to check the exposure. *ISO 200, 200mm, 1/1000 sec., f/8.*

Using the analog exposure displays

In Manual mode, an analog exposure display appears in the Information Display if it's active. This shows whether the photograph would be under- or overexposed at the current settings. Adjust shutter speed and/or aperture until the indicator is aligned with the yellow mark in the center of the display.

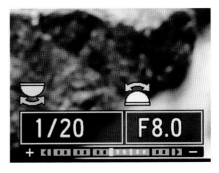

ANALOG EXPOSURE DISPLAY ⌄
Manual mode is useful for adjusting exposure in tricky light conditions. Shutter speed is shown on the left and aperture on the right.

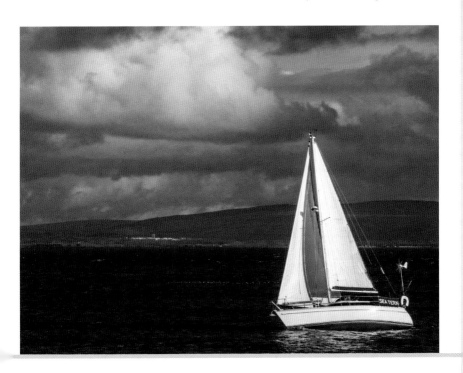

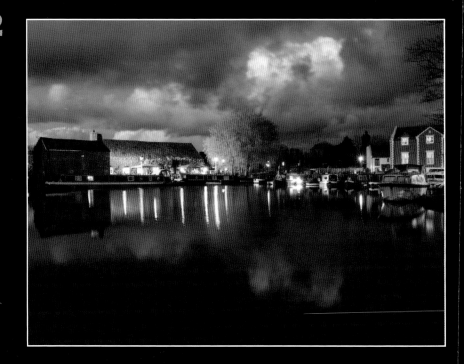

NIGHT LANDSCAPE

This photo can be compared directly with the one *on page 55*; the camera position is exactly the same and the metadata reveals that they were taken just 20 seconds apart. Yet the difference is striking—and I know which result I prefer! The crucial difference is that this image was shot in Manual mode, allowing me to make my own decisions about key settings. The overall exposure is brighter but, perhaps even more importantly, the White Balance is much warmer than the Auto setting dictated for the alternative shot. The golden hues of the artificial light contrast strongly with the blue tones of sky and water—and seem much closer to what I actually perceived when standing there. In fact, the White Balance setting here is only slightly shifted from a standard Daylight setting.

Settings
> Focal length: 28mm
> Sensitivity: ISO 400
> Shutter speed: 2 sec. (tripod)
> Aperture: f/5.6

» FOCUSING

The P7700 has a wide range of focusing options to deal with most eventualities. In some shooting modes there may be fewer options, or even no choice at all, but it's still worth understanding what's going on. It's easy to get confused by the terminology, but it all boils down to two things: how the camera focuses and where it focuses.

› Focus mode

Focus modes make the basic determination of how the camera focuses; there are five possible options. To select the focus mode, press ▼ when the camera is active. Scroll through the onscreen popup menu, highlight your selection, then press **OK** to confirm.

Selecting focus mode

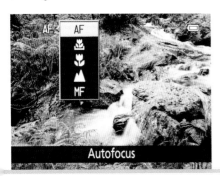

Autofocus

Note:
Focusing is a bit different when shooting movies (*see page 199*).

AF Autofocus

This is the default for the vast majority of shooting modes. Obviously, the camera focuses automatically, but there is more to it than that. For one thing, the camera can either focus just once, when you half-press the shutter-release button, or it can continually try to maintain focus. (See **Autofocus modes**, below.)

🌷 Macro close-up and 🌷 Close range only

These are also autofocus modes, but the lens is adjusted to allow it to focus closer than normal. The difference is that in 🌷 Macro close-up the lens can also shift focus to distant objects, while in 🌷 Close range only it's strictly limited to nearby subjects; this removes the possibility of the lens "hunting" as it shifts between a nearby object and a distant background.

For more on close-up focusing see Chapter 5, *page 186*.

▲ Infinity

This mode is a bit of a misnomer. The name suggests that focus is fixed at infinity, but it clearly isn't; the camera still focuses before each shot. It does appear that this mode gives priority to distant objects, relying on depth of field (*see page 144*) to limit blurring of nearer objects. However, it will focus closer if there is nothing at a great distance within the central focus area. Infinity focus is used in 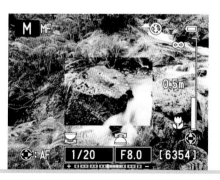 Landscape and 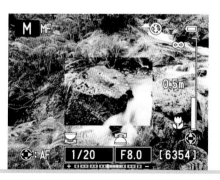 Night landscape modes, and can be manually selected in User-control modes.

MF Manual Focus

In this mode, you control the focusing. Depending on the zoom setting of the lens, you can focus as close as 1in. (2cm) to the subject. Manual Focus is slow, but it gives you confidence that you're focusing exactly where you want to. It's obviously useful for static subjects, especially close-ups, and particularly with the camera on a tripod. It's also useful for action photography as you can prefocus at a crucial spot; Manual Focus is available in 🏃 Sports mode as well as the User-control modes.

Using Manual Focus

1) Press ▼, select **MF** from the onscreen popup menu, then press **OK**.

2) The central area of the image on screen is enlarged. A distance scale appears on the right side of the screen. Press ▲ to shift focus to a greater distance, ▼ to focus closer. (If you press ◄ the camera autofocuses at the center of the frame.)

3) Press **OK**. The magnified area disappears and focus is locked. You can take multiple shots and focus remains set at this distance.

4) Press **OK** to adjust the focus again.

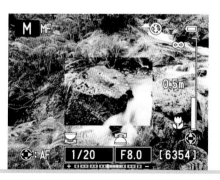

FOCAL AREA «
Enlarged central area in manual focusing.

› Autofocus modes

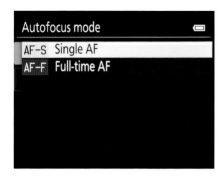

Autofocus modes—selected from the Shooting menu—determine how the camera behaves when using autofocus.

AF-S Single AF
The camera focuses when the shutter release is pressed halfway. Focus remains locked while you maintain half-pressure; if you release and press again the camera refocuses.

AF-F Full-time AF
The camera aims to maintain focus continuously, as long as the shutter-release button is not depressed (half-pressure locks the focus). This works both with moving subjects and if you move the camera. However, it's somewhat on the slow side, so don't expect 100% success with fast-moving subjects.

› AF-area modes

How the camera focuses is only half the story. The camera also needs to know *where* to focus—or, to put it another way, what your desired subject is. Most of the AF-area modes simply tell the camera what part of the frame to look in; it will then focus on the closest object it can find in that zone. This is often, but certainly not always, what you want it to do. Face-priority and Subject-tracking work a bit differently, specifically looking for a subject rather than an area of the frame.

WALK THIS WAY «
AF-F is recommended for moving subjects.
ISO 400, 200mm, 1/500 sec., f/4.

◼ Auto

Auto is the default setting in most shooting modes. Here the camera selects the focus area automatically. There are nine focus areas arrayed in the inner part of the frame and the camera will pick one or more of these. It will look for area(s) containing the closest object(s) and use these to focus.

◉ Face priority

Not surprisingly, this is the setting used in ◢ Portrait and 🌃 Night portrait; a variant is also used in 🐕 Pet portrait. The camera uses sophisticated algorithms to analyze the image and look for faces. If a single face is found the camera will focus on it; if the camera detects multiple faces it will focus on the closest. If it can't find any faces at all it will default back to ◼ Auto.

⟦ ⟧ Manual

Don't confuse this with Manual Focus. The camera still focuses automatically, but you tell it where in the frame to focus. When

⟦ ⟧ Manual is selected, you use the Multi-selector to move the focus area around the screen. There are 99 possible positions, covering most of the frame but not extending all the way to the edges. This mode lends itself to pinpoint focus on relatively static subjects and as such marries naturally with AF-S autofocus mode. It's generally quicker than Manual Focus, and does not tie you to the center of the screen as the Manual Focus magnification does.

Center (⟦◼⟧ Normal, ⟦◼⟧ Wide)

In this AF-area mode the camera focuses at the center of the frame. You can make the target area larger or smaller using the ⟦◼⟧ Normal, or ⟦◼⟧ Wide options.

⊕ Subject tracking

This mode is designed to track moving subjects, but it's not quite as simple as this bald description might imply. In effect, you have to start by telling the camera what your subject is ("registering" the subject). You also need to have all your other settings sorted before starting: any operation of the zoom control, Multi-selector, or menu button will cancel subject-registration and mean that you need to start over.

MANUAL SELECTION OF FOCUS POINT ≪
Possible focus point positions cover most of the image (limits shown by the corner markers).

1) Initially, a white-edged focus area is shown at the center of the screen. Aim the camera so this lines up with the subject, then press **OK**. If the camera can focus on this subject, the white border changes to yellow. (If it can't focus, the border flashes red.)

2) If either the subject or the camera moves, the yellow area can be seen to track it on the screen. If the camera loses focus or the subject leaves the frame, the area turns red and you need to start again.

3) Assuming the focus area remains yellow, press the shutter-release button to take a picture; the camera focuses on the target area and then shoots.

Target finding AF

Target finding AF is designed to automatically identify photographic subjects. If there are faces within the frame, it targets these, making it virtually indistinguishable from Face priority AF. However, when no faces are found, Target finding AF looks for other well-defined objects—areas with high contrast or distinct edges—and seeks to focus on these. These will often match your intended subject, but not always; the camera can't read your mind!

Target finding AF uses nine main focus areas, which cover a large area in the center of the frame. When the camera focuses, the active focus area(s) is/are outlined in green.

› Focus lock

Though the P7700's focus points cover a wide area, they do not extend to the edges of the frame, and sometimes you may need to focus on a subject that does not naturally coincide with any of the focus points. This can be done by aiming the camera at the subject, focusing, and then holding that focus while you reset the framing. This soon becomes very quick and easy.

1) Aim the camera so the subject falls within the available focus area. It's often easiest to place the subject centrally; this

TUNNEL VISION ⌄
Focus lock is often the best way to focus on off-center subjects; here I wanted to be sure the ferns at the mouth of the tunnel were in focus. *ISO 200, 42mm, 1.6 sec. (tripod), f/8.*

works whether AF-area mode is set to **Auto** or **Center**.

2) Half-press the shutter-release button to focus on the subject.

3) Maintain half-pressure on the shutter-release button (or press and hold **AE-L/AF-L**).

4) Reframe the image as desired and press the shutter-release button fully to take the picture.

> *Note:*
> By default, **AE-L/AF-L** also locks exposure as well as focus, but this behavior can be changed using AE/AF lock button in the Setup menu, *see page 123*.

› AF-assist illuminator

An AF-assist illuminator—in plain English, a small lamp—is available to help the camera focus in dim light. Its maximum range is around 6ft. 6in.–13ft. (2–4m) depending on zoom setting. It is disabled in a few Scene modes, such as 🐈 Pet portrait, and can be turned off altogether in the Setup menu.

LIGHT ON THE SUBJECT ❮
The AF-assist illuminator.

» EXPOSURE AND METERING

Getting the exposure right—in essence, making sure images are neither too dark nor too light—is vital. This depends above all on how the camera measures light levels: in other words, metering.

› Metering modes

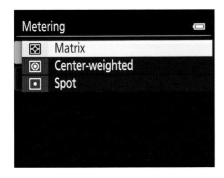

The P7700 provides three metering modes. Switch between them using the Shooting menu. Metering is also one of the standard items in My Menu. This is only possible in User-control modes: in other modes matrix metering automatically applies.

▦ Matrix metering

Matrix metering analyzes the pattern of brightness over most of the image area and uses this to deduce what type of scene the camera is looking at. It's clever, flexible, and quite honestly most of us rarely use anything else. However, if you understand how they work the other methods can sometimes prove more accurate in tricky situations.

◉ Center-weighted metering

This is a very traditional method: the camera meters from the entire frame, but gives priority to a central area. Center-weighted metering can be useful in genres like portraiture, where the key subject often occupies the central portion of the frame (although the P7700 sticks with matrix metering in Portrait mode).

⊡ Spot metering

In this mode the camera meters solely from a small circular area. This is useful where an important subject is very much darker or lighter than the background and you want to be sure it is correctly exposed. Matrix metering is more likely to compromise between subject and background.

› Focus-coupled metering

If your key subject isn't in the center of the frame, it's hard to be sure that the metering will prioritize it. A good example might be a photo of a person, standing to one side, in front of a lighter or darker background. One way to make sure that an off-center subject takes precedence in metering is to use the **AE-L/AF-L** button—provided it is still set to AE/AF lock. (See Focus lock, *page 81*.) Focus-coupled metering is another way to achieve the same thing.

Focus-coupled metering only applies when you're shooting in a User-control mode and you have the AF-area mode set Manual. Then, if you're using ▣ Matrix metering, it will give greater weight to the current focus point. If you're using ▣ spot metering the camera will meter solely from the area at the focus point.

› Exposure compensation

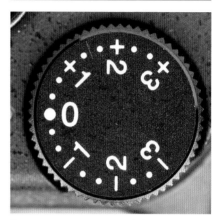

The exposure compensation dial

The P7700 will produce accurate exposures under most conditions, but no camera is infallible. It certainly won't always come up with results which exactly match the image you hoped to achieve.

All metering systems still work partly on the assumption that key subject areas have a middling tonal value (like the "gray card" inside the cover of this book), and should appear as a mid-tone in the images. With

TOR ORDER **«**

Focusing on the sunlit side of the tor helped to ensure good depth of field from front to back—and, with focus-coupled metering, this ensured the exposure leaned towards the brighter areas too. Overexposure would reduce the impact of this shot. *ISO 200, 28mm, 1/320 sec., f/8.*

subjects a long way from mid-tone, this can give inaccurate results. We've all seen brilliant white snow turn out gray. Normal metering has tried to reproduce it as mid-tones, making it darker than it should be. 🏖 Beach and 🏂 Snow modes allow for this by automatically giving extra exposure: in other words, exposure compensation.

The P7700 also makes it easy to apply exposure compensation for yourself, in almost all shooting modes. The basic principle is very simple. To make the image lighter, give more exposure—apply positive compensation. To make the image darker, give less exposure—apply negative compensation.

With a dedicated dial for the purpose, the P7700 has one of the simplest exposure compensation systems of any camera. Simply turn the dial to the appropriate value (between +3 and −3 Ev in ⅓ Ev steps). The selected value is also shown on the screen for a few seconds, and a small lamp next to the dial lights to remind you that compensation is set.

Remember to reset exposure compensation when you no longer need it; the warning lamp and the dial itself are useful reminders but it is still possible to forget.

Tip

In Manual mode, the exposure compensation dial has no effect. In Manual you can make the image lighter or darker anyway by adjusting the command dials. The other exception is ✺ Fireworks show, where the exposure is preset. The screen image dims or brightens as you apply exposure compensation, but this is not necessarily an accurate preview of the final image.

› Exposure lock

Exposure compensation isn't the only way to override or fine-tune the camera's exposure setting. Another option, which is also very quick to use, is Exposure lock. This is useful, for instance, when very dark or light areas (e.g. the sun or other bright light sources) could skew the exposure. Exposure lock allows you to meter from a more average area, by pointing the camera in a different direction, then holding that exposure while reframing the shot you want.

Using Exposure lock

1) Aim the camera (or zoom the lens) to exclude potentially problematic dark or light areas.

2) Lock exposure by pressing the shutter-release button or **AE-L/AF-L**.

3) Keep the button pressed as you reframe the image and shoot in the normal way.

By default, this procedure locks focus as well as exposure. Using the shutter-release button always does this but the behavior of **AE-L/AF-L** can be changed using AE/AF lock button in the Setup menu (*see page 123*). If you want to use **AE-L/AF-L** to lock exposure but allow the camera to refocus, choose **AE Lock only**.

› Exposure bracketing

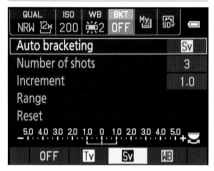

Exposure bracketing in the Quick Menu

When it's really important to get a correctly exposed shot, you can hedge your bets by shooting several frames at differing exposures, selecting the best later; this is known as exposure bracketing. In the User-control modes, the P7700 can do this automatically. Choose your options from the BKT section of the Quick Menu (*see page 39*). This allows you to choose the number of shots in a bracketed sequence (three or five shots) and the magnitude of the difference ("increment") between them.

You can bracket exposure by varying the ISO sensitivity (Sv), shutter speed (Tv), or aperture (Av), with some limitations: Av bracketing is only available in Shutter-priority mode, while Sv bracketing is only available in Manual mode.

Once the options are set, press **OK** to exit, frame the shot and press the shutter-release button. The camera takes the chosen number of shots in quick succession.

Tip

Auto bracketing is a handy feature, but sometimes it's quicker overall to twiddle the exposure compensation dial between shots. Use a tripod to make sure the shots are all framed alike. This is the only way to achieve exposure bracketing in Scene modes.

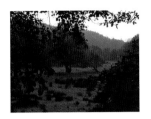
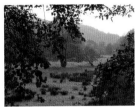
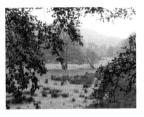

−1 Ev 0 Ev +1 Ev

Exposure bracketing. *ISO 200, 83mm, 1/250 sec., 1/125 sec., 1/60 sec., f/8 (tripod).*

› Histograms

The histogram is a graphic depiction of the distribution of dark and light tones in an image. The histogram is one of the most useful tools we have for telling us whether a shot is correctly exposed or not; it's much more precise than just looking at the full-frame playback, especially when bright sunlight makes it hard to see the screen clearly.

The P7700 can display a live histogram during shooting, and it can also be viewed during image playback by pressing ▶ to see the detail page (*see page 94*). The playback histogram is a bit squashed (not very tall) but still clear enough.

The best way to get the hang of histograms is to look at different images, perhaps on the computer when you've more time and a bigger screen to play with. Nikon View NX2 and many other apps can display clear, detailed histograms.

A histogram which is bunched up towards the left indicates a predominantly dark image; this may mean that it's underexposed or that it's a good result on a predominantly dark subject. However, if the histogram is really crammed up against the left end of the scale, this implies that areas of the image are solid black ("shadow clipping"): this is rarely welcome. Similarly, a bias to the right indicates a mainly light image. A well exposed image of an average subject will yield a nice, middling, "bell-curve" histogram. Just remember that not all subjects are average!

HISTOGRAM ⌄
A "live" histogram is available when shooting.

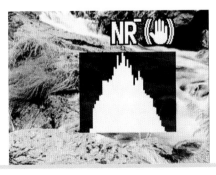

2

› ISO sensitivity settings

The ISO setting governs the camera's sensitivity to greater or lesser amounts of light. At higher ISO settings, less light is needed to capture an acceptable image. As well as accommodating lower light levels, higher ISO settings are also useful when you need a small aperture for increased depth of field (*see page 144*) or a fast shutter speed to freeze rapid movement (*see page 149*). Conversely, lower ISO settings are useful in brighter conditions, and/or when you want to use wide apertures or slow shutter speeds. Image noise (*see page 162*) does increase at higher ISO settings, and this can be very obvious in fine prints or full-screen views.

The P7700 offers ISO settings from 80 to 3200. There's an extra **Hi1** setting (equivalent to 6400 ISO), but use with care as noise becomes very obvious.

By default, the P7700 sets the ISO automatically. Only P, S, A, and M modes allow manual control.

› Auto-ISO

In Auto and Scene modes, ISO control is wholly automatic. You can also use Auto ISO in P, S, A, and M modes, and here you have some options to govern how Auto ISO works. The difference between the alternatives is the maximum ISO that can be set. The one you'll choose depends on your tolerance for image noise (*see page 162*), which is likely to be less if you view images on a large screen or make big prints.

Auto-ISO options

	Heading	Description
AUTO	Auto	Camera selects ISO in range 100–1600
🔲 ISO 200	ISO 80–200	Camera selects ISO in range 80–200 only
🔲 ISO 400	ISO 80–400	Camera selects ISO in range 80–400 only
🔲 ISO 800	ISO 80–800	Camera selects ISO in range 80–800 only
	Minimum shutter speed	Sets "trigger" value for shutter speed: camera will increase ISO when satisfactory exposure is no longer possible at selected shutter speed. Any value from 1/30 to 1 second can be set.

Setting the ISO

ISO options (manual setting and Auto-ISO options) are chosen in the Quick Menu.

1) Turn the Quick Menu Dial to **ISO** and/ or press the Quick Menu button to call up this menu.

2) Use the Main Command Dial or Multi-selector to highlight the required setting, then press **OK** to accept it.

HIGH ISO »
A high ISO setting helps avoid the use of flash while keeping the shutter speed high to deal with moving people. The flash would not have had enough range here. *ISO 3200, 28mm, 1/125 sec., f/4.5.*

The P7700's Mode Dial features three positions labelled U1, U2, and U3. These allow instant access to predetermined combinations of important camera settings.

Probably the best way to explain this is with an example. I like shooting landscapes but find Landscape mode deeply frustrating: I can't shoot RAW, I can't set a small aperture or control the focus point to maximize depth of field, I can't use flash to brighten the foreground occasionally, and so on. On the other hand, I'd prefer not to have to keep fiddling with settings such as AF area mode every time I shift from a different type of subject. With User settings I only have to set things up once, and from then on all I have to remember is that U1 is my landscape setting.

Here are the key settings I'd use for landscapes; you may of course do some things differently:

Shooting mode: Aperture-priority
Aperture: f/8
Focal length: 28mm
Photo info: show histogram
Flash mode: fill flash
Focus: Autofocus
AF mode: AF-S
AF area mode: Manual
AF assist: OFF
ISO: 100

White Balance: Direct Sunlight
Picture Control: Vivid
Image Quality: RAW.

To store User settings

1) Set the Mode Dial to **U1**, **U2**, or **U3**.

2) Press **MENU**. A new menu tab (labelled **U1**, **U2**, or **U3**) appears above the usual ones (which remain accessible as normal). Highlight this top tab and press ▶.

3) Navigate down the list of options with the Multi-selector; change any you wish to alter in the usual way. The list includes **Shooting mode**: select P, S, A, or M.

4) You can also change any settings you wish in the Quick Menu, such as **Image Quality/size** or White Balance.

5) Half-press the shutter-release button to switch to the usual shooting screen. If you're in S, A, or M mode, you can set shutter speed and/or aperture. Press **MENU** to return to the User settings menu screen.

6) When satisfied, scroll back up to **Save user settings** and press **OK**. If you want to review the settings you've chosen, move the zoom control towards **T**. Repeat this to return to the menu screen.

7) Highlight **Yes** then press **OK**. The new combination of settings is now saved and will all take effect whenever you return the Mode Dial to the appropriate position.

8) If you wish, repeat the procedure with the other two **U** positions to create two more combinations of settings.

> **Note:**
> Whenever you select U1, U2, or U3, the stored settings are just a starting point and you can adjust them as normal. One thing you can't change while in User settings is the Shooting mode, because that would require the Mode Dial to be moved off the U1/U2/U3 positions. All settings revert to the saved values next time you come back to that U mode.

Changing and resetting User settings

To create a new set of User settings for any of the three dial positions, replacing an earlier set, simply repeat the procedure above. The **Reset user settings** item in the Setup menu will restore all settings for that dial position to the camera's default values. If you reset the options for U2, for example, U1 and U3 are not affected.

2 » IMAGE PLAYBACK

The P7700's large, bright LCD screen makes image playback a pleasure, and it's also highly informative. At default settings, the most recent image is automatically displayed immediately after shooting, as well as whenever ▶ is pressed. (In Continuous Release mode, playback only begins after the last image in a burst has been captured; images are then shown in sequence.)

To view other images, scroll through them using the Multi-selector. Use ▶ to view images in the order of capture, ◀ to view in reverse order ("go back in time").

› Playback zoom

1) To zoom in, move the zoom lever towards **T**. A small navigation window appears bottom right, with a yellow rectangle indicating the area currently visible in the monitor. The first touch zooms in to 3x magnification; release the zoom lever then turn it again to zoom in further. For Large images and RAW files the maximum magnification is approximately 10x.

2) Use the Multi-selector to view other areas of the image.

3) To zoom out, move the zoom lever towards **W**. To return instantly to full-frame view, press **OK**. Or exit playback by pressing ▶ or the shutter-release button.

› Viewing images as thumbnails

To display 4 images at once, move the zoom lever towards **W**. Repeat to view 9, 16, or 72 images. Repeat again to enter Calendar View (see below).

Use the Multi-selector to scroll up and down to bring other images into view. The currently selected image is outlined in yellow. To return to full-frame view, press **OK** or move the zoom lever towards **T** as many times as necessary.

› Calendar View

An extension to Thumbnail View, Calendar View displays images grouped by the date when they were taken. Having "zoomed out" repeatedly to display 72 images, repeat once more to reach the first calendar page (date view), with the most recent date highlighted. The first picture taken on that date appears on the right of the screen. In this view, the Multi-selector can be used to navigate to different dates.

Press **OK** to view the first picture from the selected date. You can now view pictures from that date in the normal way.

In date view, if you "zoom in" you can return through the 72, 9, and 4 thumbnail screens to full-frame view.

› Viewing photo information

The P7700 records masses of information (metadata) about each image taken, and some of this can also be viewed during playback. Use **DISP** to cycle through three different views of an image:

Full-screen view shows the image with no overlaid information.

OVERVIEW ⌄
The overview page.

IN DETAIL ⌄
The detail page.

The overview page shows the image full-size with basic information overlaid (date and time of shooting, file number, image size/quality, and sequence number among images on the memory card).

The detail page shows a smaller image with a histogram (*see page 87*) below, plus a range of shooting information (shooting mode, shutter speed, aperture, ISO, exposure compensation, white balance, Picture Control, image size/quality). It also includes a highlight warning (see below).

› Highlights

On the detail page, the P7700 displays a flashing warning over any areas of the image with "clipped" highlights, i.e. completely white with no detail recorded (*see page 162*). By pressing ◄ you can

HIGHLIGHT WARNING ⌄
The black area flashes to indicate clipped highlights.

move a bar along the histogram display and the image will flash in areas which cover that section of the tonal range. If you take it all the way to the left, the flashing areas change to show shadow-clipping instead. For more about histograms *see page 87*.

› Deleting images

To delete the current image, or the selected image in Thumbnail View, press 🗑. A confirmation dialog appears. To proceed with deletion highlight **Yes** and press **OK**; to cancel, press ▶. (You can also delete images via the Playback menu, *see page 108*.)

› Protecting images

To protect or hide images, use the Playback menu (*see page 109*).

› Editing/enhancing images

There are many ways to adjust and enhance images in-camera after they've been shot, almost all of them accessed via the Playback menu. Pressing **MENU** while an image is displayed in playback takes you directly to this menu to see options which you can apply to that image. For more about image enhancement *see page 133*.

2 » USING MENUS

The menus offer many options to adapt the P7700 to your exact requirements. Apart from the Quick Menu and its subsidiary My Menu, which were introduced earlier, there are three main menus: P, S, A, or M Shooting menu, ▶ Playback menu, and ♀ Setup menu.

The Shooting menu covers shooting settings, such as metering and focusing options and release mode. It's selected from the top tab in the Menu screen, which shows the letter P, S, A, or M according to which mode is selected.

This top tab changes completely when the Mode Dial is in certain positions. When SCENE is selected, it becomes a Scene menu, from which you select the Scene mode (*see page 46*); similarly, it's an Effects menu when EFFECTS is selected. It becomes a (short) Movie menu when ▶🎥 is selected on the Mode Dial and a (longer) Movie Custom Setting menu when the dial is moved to ▶🎥 MCS.

The ▶ Playback Menu covers functions related to playback, including viewing, printing, or deleting images. To see this menu, press **MENU** when the camera is in playback mode.

The ♀ Setup menu includes essential functions like language and time settings, plus many options for customizing the camera's operation and controls.

Navigating the menus

The general procedure for navigating the menus is the same throughout.

1) To display the menu screen, press **MENU**.

2) Use ▲ or ▼ to highlight the different menus. To enter the desired menu, press ▶.

3) Use ▲ or ▼ to highlight individual menu items. To enter a particular item, press ▶ or **OK** to reveal a set of options.

4) Use ▲ or ▼ to choose the desired setting. To select, press ▶ or **OK**. In some cases it's necessary to select **DONE** and then press **OK** to make settings effective.

5) To return to the previous screen, press ◀. To exit the menu without effecting any changes, press **MENU**.

» SHOOTING MENU

Shooting menu options are only available in P, S, A, and M modes.

› Custom Picture Control

Create up to two additional Picture Controls (see page 41).

› Metering

This menu item is used to select a metering method. The options (already discussed on page 83) are: ▦ Matrix, ⊙ Center-weighted, ⊡ Spot.

› Continuous shooting

This is a slightly confusing heading, but it basically governs the options relating to how often and how frequently the P7700 releases the shutter (also known as "release mode"). Six possible release modes can be selected in this way.

⬚ Single
The camera takes a single shot each time the shutter release is fully depressed.

▦ Continuous H; ▦ Continuous M; ▦ Continuous L
The camera fires continuously while the shutter release is fully depressed. The maximum frame rate is 8fps in ▦, 4fps in ▦, and about 1fps in ▦. The number of shots the camera can capture in a continuous burst like this is limited to 6fps in ▦ and ▦, up to 30fps in ▦.

FUNCTIONS » USING MENUS / SHOOTING MENU

If you're shooting RAW images the camera can still capture six in a burst, but after shooting them, there's then a delay of up to 30 seconds while the camera catches up with writing all of these images to the memory card. This can be very frustrating, and may well lead to missing an even better shot. With JPEG images, the delay is still there but it's normally only 2 or 3 seconds.

BSS

BSS stands for Best Shot Selector. In situations where camera shake is likely to cause blurred images, such as shooting in low light or with the digital zoom, you can keep the shutter-release button depressed and the camera will shoot up to 10 frames in quick succession. It then selects the one which appears sharpest and discards the remainder.

BSS is not available when Image Quality is set to RAW. It's also not well-suited to

shooting moving subjects, as timing in relation to the action becomes virtually random, and the camera may easily discard the shot(s) which caught the action at the most interesting point.

🎞 Multi-shot 16

With one press of the shutter-release button, the camera shoots 16 pictures in less than half a second and then "tiles" them into a 4x4 mosaic. The overall size of this composite image is **5m** (2560 × 1920 pixels); you can't shoot in RAW format.

Continuous H: 120fps and Continuous H: 60fps

These modes allow you to shoot a burst of 60 frames at extremely high frame rates, capturing half-a-second (120fps) or a full second (60fps) of action. This might seem like a good way to capture "the decisive moment", but it's rarely that simple, and in any case the size of each image in the sequence is limited to **1m** (1280 x 960 pixels). However, these modes are very effective at clogging up your photo collection with hundreds of nearly identical images.

FRAME BY FRAME «

Though taken in very quick succession, you can see small differences between the individual images in this composite.

⬡ Intvl timer shooting

The camera will shoot automatically at set intervals. The resulting images can be combined into a time-lapse movie, though Nikon does not provide the software to do this.

Having selected **Intvl timer shooting** in the Shooting menu, press ▶ to choose between intervals of 30 sec., 1 min., 5 min., or 10 min. Press **OK** to continue. Then frame the shot, confirm other settings, and fully press the shutter-release button to take the first shot. To cancel or end the sequence at any time, press the shutter-release button again; until then, the camera will continue shooting as long as there is space on the memory card and power in the battery—subject to the following top limits.

Interval	Max. no. of shots
30 sec.	600
1 min.	300
5 min.	60
10 min.	30

› AF area mode

Used to select the AF-area mode (which can also be selected after pressing ▼ in shooting mode). The options (already discussed *on page 79*) are: [■] Auto; [☺] Face priority; [] Manual; Center ([■] Normal, [■] Wide); ⊕ Subject-tracking; []Target finding AF.

› Autofocus mode

Used to select the AF mode. The options (already discussed *on page 79*) are: AF-S Single AF and AF-F Full-time AF.

› Flash exp. comp

Used to make the flash output relatively dimmer or brighter, in relation to the value the camera would normally set: see Chapter 4, *page 177*.

› Noise reduction filter

› Built-in ND filter

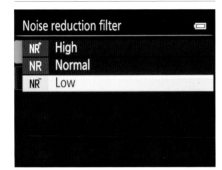

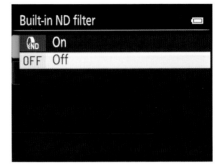

Noise reduction (NR) is a correction applied in the processing of JPEG images to reduce the appearance of image noise (*see page 162*), especially in images shot at high ISO settings. A higher NR setting will reduce the speckled appearance caused by noise, but may also smooth out fine detail, and can give images a "plastic" appearance.

You can easily perform extra noise reduction on the computer later, but it's almost impossible to restore detail which has been blurred by over-strong in-camera NR. To be on the safe side, therefore, I set NR to **Low**, but if you print or show images directly from the camera you might prefer a higher setting.

An ND (neutral density) filter reduces the amount of light reaching the sensor without causing any shifts in color balance (hence "neutral"). On many cameras this means placing an external glass filter in front of the lens but the P7700 has a built-in ND function. This can be used when the general light level is very bright and there's a possibility of overexposure, or when you want to use a slower shutter speed—a favorite application for this is in shooting waterfalls. The built-in ND filter reduces light by 3 Ev; if your slowest possible shutter speed without it was ⅛ sec. it would allow you to shoot at 1 sec. instead. You can only select it when using P, S, A, and M modes.

› Distortion control

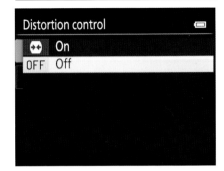

› Active D-Lighting

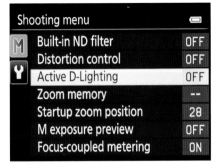

Applies a correction during JPEG processing to compensate for distortion (*see page 161*) which arises at certain focal lengths. Such distortion is only likely to be noticed where there are straight lines towards the edges of the frame, such as when shooting buildings. When shooting subjects such as portraits and the majority of landscapes, distortion will almost always go unnoticed.

The correction during processing does crop the image slightly, which is presumably why distortion control is Off by default. If images do show distortion, this can easily be corrected in most modern imaging software on the computer; this is your only option if you shoot RAW.

Active D-Lighting is designed to enhance the P7700's ability to capture detail in both highlights and shadows, in scenes with a wide range of brightness (dynamic range). In simple terms, it reduces the overall exposure in order to capture in more detail the brightest areas, while mid-tones and shadows are subsequently lightened as the camera processes the image. It tends to make pictures look more realistic, but can also make them look less punchy. Because of the extra processing required, it can cause the shooting rate to slow slightly

The options available are **High**, **Normal**, **Low**, and **Off** (default setting).

> **Note:**
> Because it affects the overall exposure, Active D-Lighting can have an impact on RAW files as well as JPEGs.

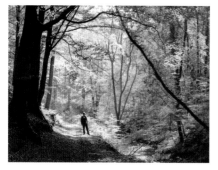

INTO THE WOODS

The same basic shot, with Active D-Lighting set to Off (top) and High. Subjectively, you may prefer either, but objectively there's no doubt that the shot with Active D-Lighting records more detail in both shadows and highlights. *ISO 320, 65mm, 1/20 sec. (tripod), f/8.*

› Zoom memory

Zoom memory can be used to make the lens zoom in steps to certain set focal lengths. To use zoom memory, hold the Fn1 button as you operate the zoom control. There are seven available settings and by default all of them are enabled: 28mm, 35mm, 50mm, 85mm, 105mm, 135mm, and 200mm. It's possible to deselect any of them using this menu item. Use **OK** to toggle each setting **On** or **Off**; press ▶ to finish.

For instance, if you uncheck 35mm, 85mm, and 135mm, zoom memory will use just the four remaining steps, each roughly double the focal length of the preceding one: this is how the shots on page 147 were taken.

› Startup zoom position

› M exposure preview

This allows you to determine the focal length the camera will zoom to when switched on. For instance, if you mostly shoot landscapes, you'll probably use the widest (28mm) setting most often so it's handy if the camera automatically sets this whenever you switch on (this happens to be the default setting anyway). On the other hand if your favorite subjects are sports or street photography, you might prefer the zoom to set 200mm initially. You can, of course, change the zoom setting at any time; this item only determines the starting setting.

The options are 28mm, 35mm, 50mm, 85mm, 105mm, 135mm, and 200mm.

If this option is **On** then, when you're shooting in Manual mode, the brightness of the shooting screen will change as you change shutter speed and aperture settings. This gives a fair preview of the exposure level of the final image, though it's not a complete substitute for image review (*see page 92*) and in particular for the histogram (*see page 87*). The default setting is **Off**.

› Focus-coupled metering

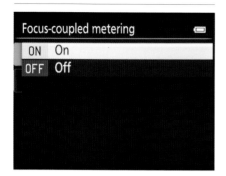

Select this option and the metering system will take greater note of the selected focus area; this only applies when **AF-area mode** (see page 79) is set to **Manual**. For more on metering in general see page 83.

› Commander mode

Used to trigger and regulate external flash units (see pages 179 and 181).

» 🎥 MOVIE MENU

This rather brief menu is available by pressing **MENU** when 🎥 is selected on the Mode Dial.

› Autofocus mode

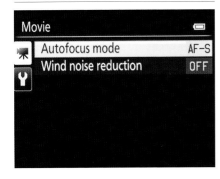

This is used to select the AF mode which the camera employs when shooting movie clips. The options are the same as in the regular Shooting menu: AF-S Single AF and AF-F Full-time AF. For more on focusing in Movie mode *see page 199*.

› Wind noise reduction

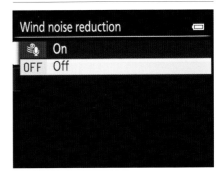

In breezy situations, wind noise may be very obvious in sound recorded with the built-in microphone. The best way to avoid this is to use a separate microphone with effective wind-baffling, like Nikon's ME-1 (*see page 213*). Failing this, the camera can process sound during recording to reduce wind noise. However, this may make other sounds fainter or more muffled as well and therefore wind noise reduction is **Off** by default.

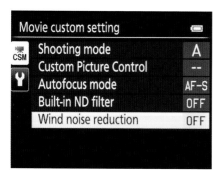

This menu is available by pressing **MENU** when ⊷₩**MCS** is selected on the Mode Dial. It includes the two options shown above under 🔘, plus the following modes.

> ### Shooting mode

Choose how your movies are shot (*see page 200*).

> ### Custom Picture Control

Allows Custom Picture Controls to be applied to movie clips, in the same way as in stills photography. In fact, this menu is exactly the same as in stills shooting (*see page 97*).

> ### Built-in ND filter

Allows the built-in ND filter to be applied during movie shooting, just as when shooting stills (*see page 100*). This allows the use of slower shutter speeds or wider apertures, both of which can be very helpful in movie shooting (*see page 201*).

» ▶ PLAYBACK MENU

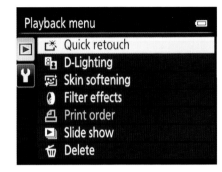

The P7700's Playback menu contains options which affect how images are viewed, stored, deleted, and printed. In addition, there are a number of options which can be used to modify or enhance existing images; these are dealt with separately under Image enhancement, starting *on page 133.*

The Playback menu is available by pressing **MENU** when the camera is in Playback mode—in other words, press ▶ first.

› Quick retouch

See Image enhancement, *page 134.*

› D-Lighting

See Image enhancement, *page 134.*

› Skin softening

See Image enhancement, *page 135.*

› Filter effects

See Image enhancement, *page 135.*

› Print order

This allows you to select image(s) to be printed when the camera is connected to—or the memory card is inserted into—a suitable printer, i.e. one that complies with the DPOF (Digital Print Order Format) standard. For more on printing generally see Chapter 8, *page 230.*

› Slide show

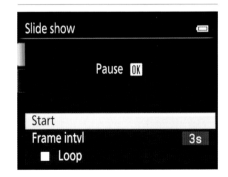

Enables you to display images as a standard slide show, either directly on the camera's

own screen or when playing back through a TV. All the images on the memory card (except hidden images) will be played in chronological order. You can set the interval to 2, 3, 5, or 10 seconds using the Frame **intvl** tab. When the interval is set, select **Start** and then press **OK** to begin the slide show.

To skip ahead, or skip back, while a slide show is playing, press ▶ or ◀ respectively. A quick press takes you back/forward by one image, while holding the button lets you scroll rapidly.

If you press **OK** during the slide show, the slide show is paused; press ◀ to highlight the "play" symbol then press **OK** to resume; if the "stop" symbol is highlighted, pressing **OK** ends the slide show. Pressing **MENU** is another way to exit.

› Delete

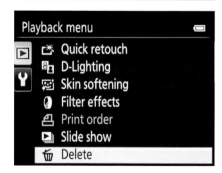

Allows images stored on the memory card to be deleted, either singly or in batches.

When you first enter this menu item, the screen shows five options: **Erase selected images**; **Erase all images**; **Entire sequence**; **Erase selected NRW images**; **Erase selected JPEG images**.

Erase all images is completely self-explanatory; if you select this option and press ▶, the next screen is a confirmation dialog. If you select **Yes** and press **OK** all images on the card will be deleted. The only exceptions are images which have been protected (see below).

Choosing one of the other options leads to a thumbnail screen. If you select **Erase selected NRW images**, only NRW (RAW) images on the memory card are displayed, and similarly for JPEG images.

Navigate through the displayed images using ▶/◀ or by rotating the border of the Multi-selector. The selected image is outlined with a yellow border. Use ▲/▼ to mark that image for deletion: a yellow check-mark appears.

When you've selected all the images you want to delete, press **OK**. A confirmation dialog appears. If you highlight **Yes** and press **OK** all the selected images will be deleted.

Note:
Individual images can be deleted in the normal course of playback, and this is usually more convenient (*see page 95*).

› 🔒 Protect

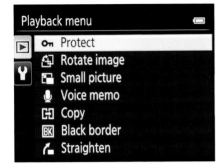

This option protects selected images against accidental deletion. When you select this item from the Playback menu, a screen of thumbnails appears. Navigate through them just as described above, using ▲/▼ to mark selected image(s) to be protected. When satisfied, press **OK**. The selected images will now be preserved even if you choose **Erase all images** from the **Delete** menu.

Warning!

Protected images *will* be deleted when the memory card is formatted.

› Rotate image

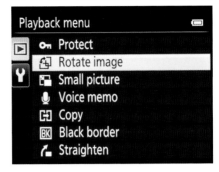

Generally, images will appear the right way up on playback. If occasional images don't, use this menu to rectify them. When you select this item, the camera displays images currently on the memory card as thumbnails. Navigate through them using ▶/◀. Press **OK** to see the selected image larger, and use ▶/◀ to rotate it. Press **OK** to confirm; this also returns you to the top level Playback menu screen. Repeat the whole process to rotate further image(s).

› Small picture

See Image enhancement, *page 137.*

› Voice memo

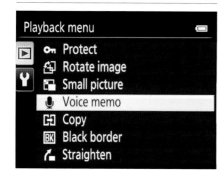

You can add a voice memo of up to 20 seconds duration to any photo on the memory card.

1) Select the image first, in normal playback, then press **MENU**.

2) Select **Voice memo** and press ▶.

3) Press and hold **OK** to start recording. Press **OK** again to stop; otherwise recording automatically ends after 20 seconds.

If a photo already has a voice memo attached, you can play this back by following steps 1 and 2 above. Then press **OK** to play. Use the zoom control to adjust volume if required.

You can't directly record over an existing voice memo: you need to delete it first and then follow the above procedure and then record a new memo. To delete a voice memo, follow steps 1 and 2 above,

then press 🗑. Select **Yes** in the dialog screen which appears and press **OK** to confirm deletion.

› Copy

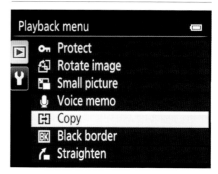

This allows you to copy an image or images from the camera's internal memory to a memory card, or vice versa.

1) In the first screen that appears, select the **Copy** direction, then press ▶.

2) Choose between **Selected images** and **All images** and press ▶.

3) If you chose **All images**, choose **Yes** in the confirmation dialog then press **OK** to start the copy process.

4) If you chose **Selected images**, a screen of thumbnails appears. Use ▶/◀ to scroll through them and ▲/▼ to mark image(s) to be copied. Then press **OK**. Choose **Yes** in the confirmation dialog then press **OK** to start the copy process.

› Black border

See Image enhancement, *page 138*.

› Straighten

See Image enhancement, *page 138*.

› NRW (RAW) processing

See Image enhancement, *page 138*.

› Sequence display options

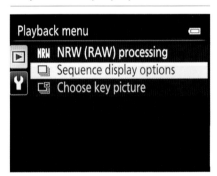

The P7700 has several modes in which a series of pictures can be shot as a non-stop burst, including all the various modes labelled Continuous (*see page 97*). Continuous shooting is also possible in 🏃 Sports mode by simply keeping the shutter release depressed (*see page 49*), and in 🐾 Pet portrait (*see page 63*). The camera tags each such burst as a sequence. By default, it will only display one image—termed a "key picture"—to represent the sequence. This is often a good thing, as a sequence can be up to 60 frames, which will thoroughly clutter your playback screen.

However, you may sometimes want to see all the pictures in a sequence. This will probably apply when sequences are relatively short, as they often are. Use this menu to display **Individual pictures** rather than **Key picture only**.

› Choose key picture

Following on from the previous item, this allows you to select any image from a sequence to serve as the Key picture. To make this selection you must select the sequence from the playback screen first, before pressing ▶ to enter the menu.

The Setup menu controls many important camera functions, though many are ones you will need to access only occasionally, if at all. It contains 38 items, spread over 6 screens, so you might consider adding regularly-used items (e.g. **Format card**) to My Menu for speedier access: see **Customize My Menu** on page 126.

> ### Tip
>
> *To maximize battery life, select None. Some images, such as RAW files, cannot be selected for the welcome screen—but you can always make a JPEG copy of a RAW image (see page 110).*

› Welcome screen

Determines whether the camera displays anything on the screen at startup. The default option is **None**: the screen remains blank until the camera is ready to shoot. Alternatives are **COOLPIX** (the screen displays the Coolpix logo) and **Select an image** (display an image).

To display an image, highlight **Select an image**, then press ▶. The screen shows thumbnails of images on the memory card/internal memory. Navigate through

them using ▶/◀. Use ▲/▼ to mark the selected image, then press **OK**. The camera retains this image for the welcome screen even if the original is later deleted from memory (e.g. by formatting the memory card).

› Time zone and date

The camera records the date and time of every image as part of the metadata (*see page 94*). To make sure these are correct,

use this menu. You're prompted to make these settings the first time you switch on the camera, so thereafter you should only need to visit this item when you travel to a different time zone.

Set your home time zone first, then set the time correctly. Then, if you travel to a different time zone, just change the time zone setting and the time will be corrected automatically.

This is done by selecting **Travel destination** in the **Time zone** screen and then selecting the appropriate time zone.

If daylight saving time is in operation at the destination, press ▲. The press **OK** to set the new time zone. On return, simply select **Home time zone** and press **OK**

The **Date format** section lets you specify how the date is displayed (Y/M/D, M/D/Y, or D/M/Y).

› Monitor settings

Controls settings relating to the display on the LCD screen during shooting.

Heading	Options	Notes
Image review	On (default)	Most recent image is displayed on screen for a few seconds immediately after shooting.
	Off	No image displayed, screen returns immediately to shooting mode: best for readiness for the next shot.
	Tone level information	Image is displayed on screen immediately after shooting, along with histogram and other shooting information.
Brightness	5 steps	Adjust monitor brightness. A brighter setting may be useful when shooting in bright sunlight. The default is the median setting (3).
Photo info	Virtual horizon Histogram Grid lines	Determines whether these indicators are shown or hidden during normal shooting. There are separate options for when the monitor is set to **Show** or **Hide info**.
Virtual horizon display	Circle Bars	Determines how the Virtual horizon is displayed (if enabled).

2

Photo info options

> ## Print date

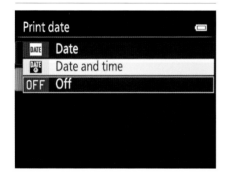

If enabled, the camera prints **Date** or **Date and time** in the bottom right corner of the image (JPEG only: info is not imprinted on NRW (RAW) images).

Tip

Information on time and date of shooting is always recorded in image metadata, without needing to spoil the visible image.

> ## Self-timer: after release

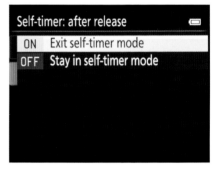

After taking a shot with the self-timer or delayed remote control, this determines whether the timer/remote remains active for subsequent shots, or turns off (i.e. the camera reverts to normal shooting). The options are self-explanatory: **Exit self-timer mode** and **Stay in self-timer mode**. **Exit** is the default setting.

› Vibration reduction

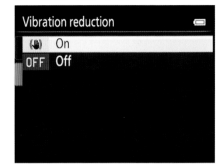

Determines whether Vibration Reduction (VR) is enabled or not. It's normally worth leaving it **On** for handheld shooting but it is recommended to turn it **Off** when shooting on a tripod.

If you regularly alternate between handheld and tripod shooting, continually switching VR on and off in the Setup menu is a hassle; to speed up access you could add **Vibration reduction** to My Menu (*see page 126*) or consider creating "Handheld" and "Tripod" modes in User settings (*see page 90*).

› AF assist

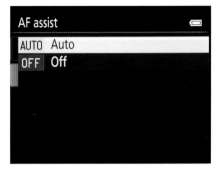

The AF-assist illuminator (*see page 82*) is available to help the camera focus in dim light. It will illuminate automatically when required if this menu is set to **Auto**; alternatively you can turn it **Off**. Its maximum range is around 13ft. (4m). The AF-assist illuminator is always **Off** in Museum or Pet portrait mode, and when shooting movies.

› ISO sensitivity step value

› Digital zoom

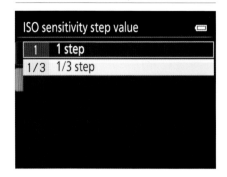

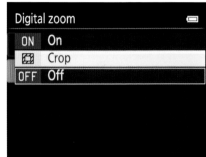

Determines whether the ISO sensitivity (*see page 88*) can be changed by larger (1 Ev) or smaller (⅓ Ev) steps.

Enables or disables the digital zoom, as discussed on *page 32*. Options are **On** (the default setting), **Crop**, and **Off**.

Heading	Notes
Auto (default setting)	Zoom operates normally when shooting stills, more slowly when shooting movies.
Normal	Zoom operates normally when shooting both stills and movies.
Quiet	Zoom operates more slowly when shooting both stills and movies.

Tip

Under Auto or Normal settings, there's some manual control over zoom speed depending on whether you push the lever all the way over (faster) or only part way (slower).

› Zoom speed

Determines the speed at which the lens can zoom in or out. Slower settings are quieter, which is an advantage particularly when shooting movies and using the built-in microphone.

› Fixed aperture

Zooming the lens normally causes the aperture to shift somewhat. If this item is turned **On** (it's **Off** by default) then the camera seeks to maintain the chosen aperture as much as possible. This only applies in A or M modes, which are the only modes in which you can directly select the aperture.

› Sound settings

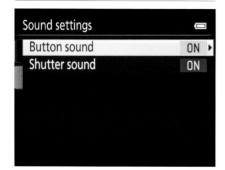

Determines whether the camera makes certain sounds.

Heading	Notes
Button sound	**On** or **Off** applies to all the following sounds: Setting beep Focus beep Error beep Startup sounds.
Shutter sound	Turns simulated shutter sound **On** or **Off**.

Note:
Even if **Shutter sound** is **On**, the simulated sound is disabled in certain modes (e.g. Pet portrait, Backlighting/HDR). Try using one of these modes—or just turn this item **Off**—to hear what the real shutter sounds like.

› Record orientation

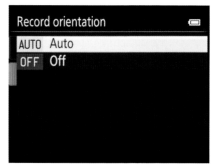

This determines whether or not the camera records information on whether each shot was taken in landscape or portrait orientation. If it's turned **Off**, all pictures will be displayed in landscape orientation ("wide") both on the monitor and when imported to a computer.

› Rotate tall

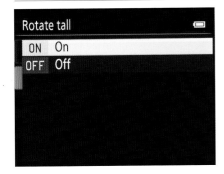

› Auto off

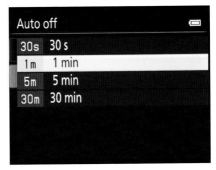

Following on from the previous item, this enables you to determine whether images recorded in portrait ("tall") format will be displayed the "right way up" during playback. If set to **Off**, these images will not be rotated, meaning that you need to turn the camera through 90° to view them correctly. If set to **On**, which is the default, these images will be displayed the right way up but, because the screen is rectangular, they will appear smaller. **On** is most useful when displaying images through a TV (*see page 229*).

The selection in this item does *not* affect how images appear when imported to a computer.

Determines the interval before the camera enters standby mode (*see page 27*). A shorter time is good for battery life. Apart from the default setting (1 min.), the options are 30 sec., 5 min., and 30 min.

2

› Format card

› Language

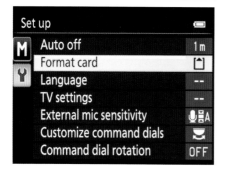

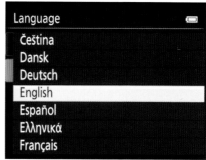

Formatting the memory card is required when you insert a new card or one that's full of images; as it's such a fundamental operation, it was covered *on page 28*.

If you shoot lots of images, this can be the most frequently used item in the Setup menu, raising the obvious question: why is it buried on page 3? Fortunately it's possible to add it to My Menu (see Customize My Menu *on page 126*).

Sets the language (choice of 31) which the camera uses in menus and other displays. You're prompted to confirm this the first time you switch on the camera, and most people will never need to change it again.

> **Note:**
> To format the camera's internal memory instead, use this item when there's no memory card inserted. The heading changes to **Format memory**.

> TV settings

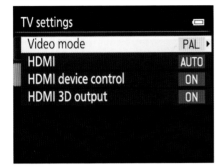

Determines settings relating to connecting to standard or HD TV sets.

> External mic sensitivity

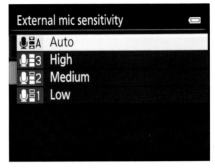

Applies when an external microphone is connected in Movie mode. The normal setting is **Auto** but if you want to maintain a consistent recording level you can switch to **Low**, **Medium**, or **High**.

Heading	Options	Notes
Video mode	NTSC PAL	Used when connecting to standard (non-HD) TV sets: NTSC is used in North America and Japan, PAL in most of the rest of the world.
HDMI	Auto (default) 480p 720p 1080i	Sets the camera's output to match the HDMI device. You can get this information from that device's specs or instructions. Normally, Auto will achieve the best match automatically.
HDMI device control	On (default) Off	Applies when connected to an HDMI-CEC television, and allows the TV remote to be used to navigate through images.
HDMI 3D output	On (default) Off	Enables playback of images in 3D Photography mode (*see page 64*).

› Customize command dials

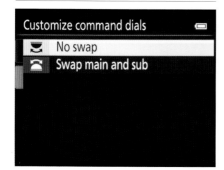

In S, A, and M modes, the command dials are used to set shutter speed and/or aperture. By default, the Main Command Dial controls shutter speed and the Sub-command Dial controls aperture. Selecting **Swap main and sub** in this menu reverses these roles.

› Command dial rotation

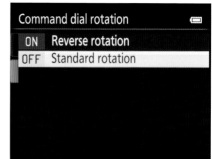

You can also change the direction of rotation of the command dials—for example, whether turning the Sub-command Dial clockwise makes the aperture smaller or larger.

› Multi-selector right press

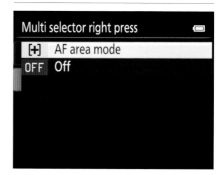

By default, in User-control modes, pressing ▶ brings up the AF-area mode selection dialog. This can be confusing if you've

previously set AF-area mode to Manual (e.g. through My Menu), in which case you'll be using the Multi-selector to set the focus point. To avoid such conflict, set **MS right press** to **Off** in this menu. However, this means you'll only be able to select AF-area mode through the Shooting menu (at least it's on the first page) or My Menu (*see pages 79 and 99*).

› Delete button options

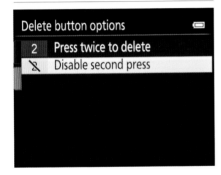

Normally, pressing 🗑 brings up a confirmation dialog; you must select **Yes** and then press **OK** to confirm deletion. To speed up the process, you can opt for **Press twice to delete**; this means you simply need to press 🗑 again to delete the image. This does make it slightly easier to delete images inadvertently, which is why the default setting is **Disable second press**.

› AE/AF lock button

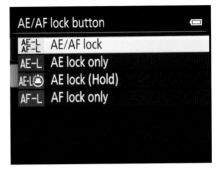

Normally, pressing **AE-L/AF-L** during shooting locks both exposure and focus settings, but you can change the way this button behaves.

Heading	Notes
AE/AF lock (default)	Press and hold button to lock focus and exposure.
AE lock only	Press and hold button to lock exposure (*see page 85*).
AF lock only	Press and hold button to lock focus (*see page 81*).

› Customizing the FUNC buttons

The FUNC (function) buttons, Fn1 (on the front of the camera) and Fn2 (right side of the top plate), can be set to perform various operations. Fn1 is used in conjunction with the shutter-release button or Main Command Dial, Fn2 on its own.

Fn1 + shutter button

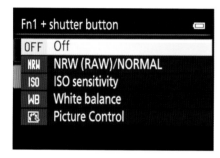

The options below are available when you hold Fn1 and the shutter-release button.

Fn1 + command dial

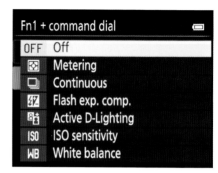

The options in the table on the opposite page are available when you hold Fn1 and rotate either of the command dials.

Note:
Settings only appear if the shooting info screen is set to **Show info** (see page 30).

Heading	Notes
Off (default)	Pressing Fn1 and shutter-release button has no effect.
NRW	A quick way to take a shot or two at different quality settings: If Image Quality is set to JPEG (Fine or Normal), shot will be taken at NRW (RAW) instead. If Image Quality is set to NRW, shot will be taken at JPEG (Normal) instead. If Image Quality is set to NRW+JPEG, no change.
ISO	Shot will be taken using ISO Auto, regardless of previous setting.
WB	Shot will be taken using Auto White Balance, regardless of previous setting.
⬛	Shot will be taken using Standard Picture Control, regardless of previous setting.

Heading	Notes
Off (default)	No effect.
Manual focus	Adjust manual focus by rotating command dial (focus mode must be set to Manual beforehand).
Metering	Change metering mode by rotating command dial.
Continuous	Choose between single, continuous, and self-timer options by rotating command dial.
Flash exp. comp.	Change Flash exposure compensation level by rotating command dial.
Active D-Lighting	Change Active D-Lighting setting by rotating command dial.
ISO sensitivity	Change ISO sensitivity setting by rotating command dial.
White balance	Change White Balance setting by rotating command dial.
Picture Control	Change Picture Control by rotating command dial.
Vibration reduction	Toggle Vibration Reduction on or off by rotating command dial.

Fn1 + selector dial

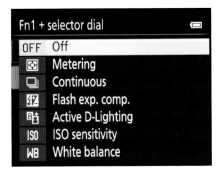

You can also hold Fn1 and rotate the outer dial of the Multi-selector. The settings which can be assigned to this are exactly the same as for Fn1 + command dial.

Fn1 guide display

If this is set to **On** (the default setting), and you press Fn1 as you rotate the command dial or selector dial, the shooting info screen clearly shows the settings being changed (in the lower right quarter).

Fn1 guide display in action: Fn1 and the selector dial are being used to choose the ISO setting

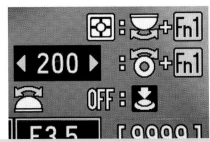

Fn2 button

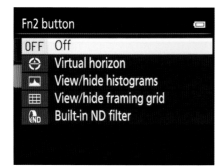

> Customize My Menu

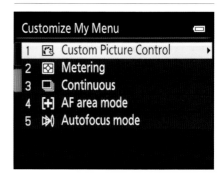

The following options can be made available (in shooting mode) when you press Fn2. Repeated pressing toggles the selected function on or off.

As you gain experience with the P7700, you may find that you use certain items in the Shooting or Setup menus regularly. Constantly scrolling through the menus to find them can become irksome. One possibility is to add key items to My Menu (*see page 40*), making them quickly accessible without scrolling. However, My Menu is limited to five items, so you'll have to jettison an existing item to add a new one; this requires careful thought.

Heading	Notes
Off (default)	No effect.
Virtual horizon	Show or hide the Virtual horizon for assistance in levelling the camera.
View/hide histograms	Show or hide a histogram.
View/hide framing grid	Show or hide a framing grid.
Built-in ND filter	Apply or remove the built-in ND filter.

Customizing My Menu

1) Highlight **Customize My Menu** and press ▶. The screen shows the five items currently enabled in My Menu. (By default: **Custom Picture Control**; **Metering**; **Continuous**; **AF area mode**; **Autofocus mode**.)

2) Scroll up or down to select an item and press **OK**. The screen shows all the items which can be added to My Menu, including many items from the Shooting menu and a few from the Setup menu.

3) Select the item you want to add to My Menu and press **OK**. It will replace the one you selected in Step 2.

4) The screen now shows the revised lineup of My Menu. To make further changes, repeat steps 2 and 3. When finished, press ◀ to exit.

› Reset file numbering

Normally, each image you take is assigned a unique number, starting with 0001. It's only when you reach 9999 that the camera has to resume from 0001 (creating a new folder at the same time). With this menu you can reset file numbering to 0001 at any time; this automatically creates a new folder too.

› GPS options

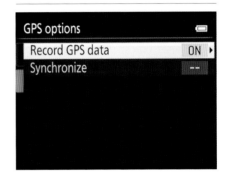

This menu item is only relevant when a GPS unit (see page 213) is attached.

Record GPS data makes the GPS active, allowing GPS info to be recorded with images.

Synchronize allows the GPS to set the camera's date and time. It only works if Record GPS data is **On** and the camera is already receiving data. Make sure the Time zone setting (see page 112) is correct.

› Eye-Fi upload

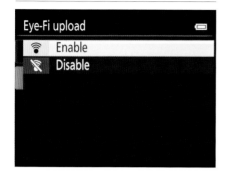

Used to set up a WiFi network connection using an Eye-Fi card (*see page 228*).

› MF distance indicator units

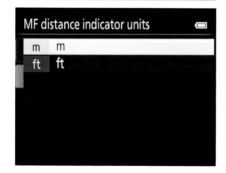

Determines whether distance units are shown in meters (default) or feet when using Manual Focus (*see page 78*).

› Reverse indicators

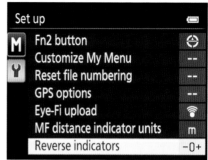

When shooting in mode M, the exposure indicator (*see photo on page 75*) normally shows underexposure to the right and overexposure to the left. You can reverse this display using this menu.

› Flash control

› Reset all

Setting to **Auto** means that the built-in flash will operate normally, except when an external flashgun is attached and switched on, in which case this overrides the built-in unit. Setting this to **Off** effectively disables the built-in flash completely, even if the attached Speedlight is turned off.

This offers a speedy way to reset most shooting and menu settings (see the table below) to default values.

Heading	Default setting/notes
Shooting screen options	
Flash mode	Auto
Self-timer/smile -timer/remote	Off
Focus mode	Autofocus
Quick menu options	
Image quality	JPEG Normal
Image size	12M
Movie options	HD 1080p
ISO sensitivity	Auto

2

Heading	Default setting/notes
Minimum shutter speed	None
White balance	Auto (normal)
Auto bracketing	Off
Picture Control	Standard
Shooting menu options	
Metering	Matrix
Continuous	Single
Interval timer shooting	When Interval timer shooting is selected, 30 sec. interval applies until changed.
AF-Area mode	Center
Autofocus mode	Single AF
Flash exposure compensation	0.0
Noise reduction filter	Normal
Built-in ND Filter	Off
Distortion control	Off
Active D-Lighting	Off
Zoom memory	All available values checked
Startup zoom position	Off
Focus-coupled metering	On
Commander mode	Flash mode: Standard flash, Flash control mode: TTL
Setup menu options	
Welcome Screen	None

Monitor settings	Image review	On
	Brightness	3 (median setting)
	Photo info	Virtual horizon, histogram, gridlines all hidden.

Heading	Default setting/notes
Virtual horizon display	Circle
Print date	Off
Self-timer: after release	Exit self-timer mode
Vibration reduction	On
Motion detection	Off

Heading	Default setting/notes	
AF assist	Auto	
ISO sensitivity step value	1 Ev	
Digital zoom	On	
Zoom speed	Auto	
Fixed aperture	Off	
Sound settings	Button sound	On
	Shutter sound	On
Record orientation	Auto	
Rotate tall	On	
Auto off	1 min.	
TV settings	HDMI	Auto
	HDMI device control	On
	HDMI 3D Output	On
External mic sensitivity	Auto	
Customize command dials	No swap	
Command dial rotation	Standard	
Multi selector right press	AF area mode	
Delete button options	Disable second press	
AE/AF lock button	AE/AF lock	
Fn1 + shutter button	Off	
Fn1 + command dial	Off	
Fn1 guide display	On	
Fn2 button	Off	
Customize My Menu	Default headings are: Custom Picture Control; Metering; Continuous; AF area mode; Autofocus mode.	
Record GPS data	On	
Eye-Fi upload	Enable	
MF distance indicator units	Metres	
Reverse indicators	+0– (overexposure shown to left)	
Flash control	Auto	

Heading	Default setting/notes
Scene/Special Effects mode options	
Scene menu	When SCENE is set on Mode Dial, Scene auto selector applies until mode is changed in Scene menu
Night landscape	Handheld
Hue adjustment in Food mode	Median setting
HDR in Backlighting	Off
Pet portrait	Pet portrait auto release On
	Continuous Continuous
Special Effects	When EFFECTS is set on Mode Dial, Creative monochrome is in effect until mode is changed in Effects menu.
Other options	
Paper size	Use default paper size for print order
Frame intvl for slide show	3 sec.
Sequence display options	Key picture only

> ## Firmware version

Firmware is the onboard software which controls the camera's operation. Nikon issues updates periodically. This menu shows the version presently installed, so you can verify whether it is current.

When new firmware is released, download it from the Nikon website and copy it to a memory card. Insert this card in the camera then use this menu to update the camera's firmware.

> **Note:**
> Firmware updates may include new functions and new menu items, which can make this *Expanded Guide* (and the Nikon manual) appear out of date.

» IMAGE ENHANCEMENT

The P7700 gives many options for adjusting and enhancing images in-camera. These essentially divide into two kinds. First, there are settings which are applied before shooting, and affect how the camera processes the image. We've already mentioned Nikon Picture Controls as an important example. However, these can only be accessed when shooting in P, S, A, or M modes. In Auto and Scene modes, image processing options are predetermined.

The second class of enhancement is applied to images which have already been taken. These changes don't alter the original photo but create a retouched copy. There's particular potential for confusion between Active D-Lighting (pre-shoot) and D-Lighting (post-shoot): both are aimed at tackling the problems posed by scenes with a wide range of brightness (dynamic range).

Active D-Lighting is accessed from the Shooting menu (*see page 101*). D-Lighting, like other post-shoot adjustments, is accessed from the Playback menu.

Some of the effects you can apply using Special Effects modes (*see page 65*) can also be reproduced post-shoot (see below).

› Post-shoot enhancement

Post-shoot enhancement (retouching) does not modify the original image; instead it creates a copy to which the changes are applied. The majority of retouching options can only be applied to JPEG images; however, you can always use the NRW (RAW) processing item to create a JPEG copy from a RAW image, and then apply further effects to the copy.

The other restriction is that images created with a non-standard aspect ratio (3:2, 16:9, or 1:1) aren't available for retouching, except for the Black border feature. The same applies to still frames extracted from movie clips, and shots taken with the Easy panorama or 3D photography modes.

If you select one of the retouching options in the Playback menu straight after viewing an image, the camera will automatically display that image for retouching. You can't select multiple images to apply an effect simultaneously; this is something you can only do when processing on a computer, and then only with the right software.

In most cases, further retouching can be applied to the copy you create. There are some restrictions, like the obvious one that you can't apply NRW (RAW) processing because the copy isn't a RAW image. You

can't apply Quick retouch and D-Lighting together either (presumably because Quick retouch includes D-Lighting anyway). A few other restrictions will be mentioned as they arise.

› Quick retouch

Provides basic one-step retouching for a quick fix, boosting saturation and contrast. It looks as if D-Lighting is applied automatically to help maintain shadow detail. The screen shows the original on the left and previews the retouched result on the right. Use ▲ and ▼ to increase or reduce the strength of the effect, then press **OK** to create the retouched copy.

› D-Lighting

D-Lighting is applied after shooting and creates a retouched copy. Like Active D-Lighting, it aims to deal with high-contrast subjects and its primary effect is to lighten the shadow areas of the image. However, because it affects the original image exposure, Active D-Lighting is better at dealing with over-bright highlights.

The D-Lighting screen shows a side-by-side comparison with the original image on the left and a preview of the retouched version on the right. Use ▲ and ▼ to select the strength of the effect: High, Normal, or Low. Press **OK** to create a retouched copy.

› Skin softening

Skin softening is designed to smooth out the appearance of skin blemishes such as spots, freckles, and wrinkles. This is of course ethically debatable, to say the least!

When you select an image, the camera will show a screen with the face centered. Use ▲ and ▼ to select the strength of the effect—High, Normal, or Low; it may be hard to see any effect at this stage. Press **OK** to see a larger preview. Press **OK** to create a retouched copy, or press **MENU** to go back to the previous screen.

You can also enhance additional faces, using ◀/▶ to jump between them.

Skin softening is applied automatically in 🎭 Portrait and 🌃 Night portrait modes.

Tip

The camera must be able to detect the face(s) automatically; if it can't do this (perhaps because the subject is not facing the camera or just not clear enough) you can't select it manually.

› Filter effects

Applies any of a range of visual effects; some of these are similar to certain Special Effects modes.

Filter name	Extra options	Notes
Soft	Wide/Normal/Narrow	Creates a soft-focus effect. "Narrow" applies over outer edges of the image, "Normal" over most, "Wide" only leaves the very center of image looking sharp. In pictures taken with face detection active, faces remain sharp and other areas are blurred.
Selective color	Choose color from palette	Similar to ✒ Selective Color in Effects modes: select particular color(s) using a palette on the left of the LCD screen; other hues are rendered in monochrome.
Cross screen	None	Creates a "starburst" effect around light sources and other very bright points (like sparkling highlights on water).
Fisheye	None	Creates a highly distorted effect, roughly mimicking use of a fisheye lens on a DSLR camera. Objects at edges of frame may disappear from the image.
Miniature effect	None	Mimics the current fad for images with extremely small and localized depth of field (*see page 144*), making real landscapes or city views look like miniature models. It usually works best with photos taken from a high viewpoint, which typically have clearer separation of foreground and background. Objects to remain sharp should be on the mid-line of the original image.
Painting	None	Similar to 🖼 Painting in Effects modes (and similarly ugly).
Vignette	None	Darkens the corners of the image; this often enhances an "antique" look.

Fisheye

Vignette

› Small picture

```
Playback menu                  ▭
┌──┐  ⊶ Protect
│ ▷│  ⊞ Rotate image
├──┤  ⊡ Small picture
│ Y│  ◉ Voice memo
└──┘  ⊞ Copy
      🄱🄺 Black border
      🔸 Straighten
```

Size (pixels)	Possible uses
640 x 480	Display on standard (not HD) television.
320 x 240	Display on mid-range mobile devices.
160 x 120	Display on small-screen mobile devices like many mobile phones.

This option creates a small copy of the selected picture(s), suitable for immediate use with various external devices, as well as for Web and email use. Three possible sizes are available. Even the largest of these is inadequate for devices like the iPad and the latest iPhones (don't worry: these will display full-size photos beautifully).

Copies created with Small picture are not available for further retouching.

› Black border

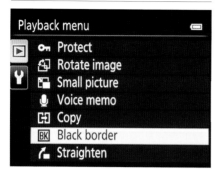

Self-explanatory: adds a black border around the copy image. Options are Thin, Medium, and Broad. Unfortunately there's no preview of the results so you'll just have to try it and see. Copies created with Black border are not available for further retouching (except Small picture), so if you want to combine with any other effect, apply that first.

› Straighten

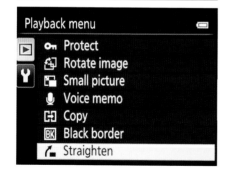

It's best to get horizons level at the time of shooting, but it doesn't always happen. This option allows correction by up to 15° in 1° steps. Use ▶ to rotate clockwise, ◀ to rotate anticlockwise. Inevitably, this crops the image. As usual, press **OK** to create the retouched copy, or **MENU** to exit.

› NRW (RAW) processing

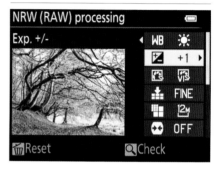

This option creates JPEG copies from RAW originals. It's no substitute for full RAW processing on a computer (see page 225) but can be really valuable in creating quick copies for immediate use. The processing options do give considerable control over the resulting JPEG image.

The screen shows a preview image, with processing options in a column on the right. The options are: White balance; Exposure +/−; Picture Control; Image quality; Image size; Distortion control; D-Lighting. When satisfied with the previewed image, select **EXE** and press **OK** to create the JPEG copy.

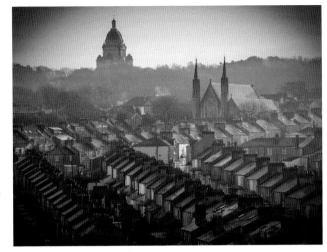

VIGNETTE »
Reducing saturation in NRW (RAW) processing and then adding a Vignette in Filter Effects gives a photo taken in 2013 an aged look.
ISO 200, 135mm, 1/400 sec., f/8.

Copies created with NRW (RAW) processing are available for further retouching.

› Crop

This is an unusual retouch option, as it is not accessed from the Playback menu but direct from regular image playback. As you already know, when playing back images you can zoom in using the zoom control, and move around the screen using the Multi-selector.

At any time during this process, if you press **MENU** you'll see a dialog asking if you want to Save this image as displayed. Highlight **Yes** and press **OK** to save the cropped image.

Naturally, as cropping just uses a portion of the image, the resulting copy is smaller (sometimes much smaller) than the original.

Copies created with Crop are not available for further retouching (except Straighten or Black border).

Chapter 3
IN THE FIELD

3 IN THE FIELD

At a basic level, cameras like the P7700 can usually be relied upon to get focusing and exposure right. However, there's a big difference between photos that "come out" and those that turn out exactly the way you want them. A fundamental thing to remember—and this is true of all cameras— is that the camera does not simply record what you see.

We could call this the "point and shoot fallacy". Cameras, lenses, and digital image sensors do not work in the same way as the human eye and brain. Take motion, for example; we see movement but the camera records a still image. Once we understand that cameras see differently, we can make it a strength, not a weakness. Many of the best photographs work precisely because they don't just mimic what the unaided eye sees. There are no "point and shoot" cameras, only "point and shoot" photographers.

Understanding how light works, how lenses and digital images behave, all makes it easier to take charge and realize your own vision. Experimenting with Scene modes is a good place to start; just try shooting the same subject using different modes to see how different the results can be. Program mode leaves the camera in charge of the key shooting parameters, aperture and shutter speed, while allowing you to make choices over other important settings such as White Balance, Picture Controls or Active D-Lighting. Aperture-priority and Shutter-priority modes give control over these vital parameters but still allow the camera to determine correct exposure.

Settings

> Focal length: 133mm
> Sensitivity: ISO 200
> Shutter speed: 1/400 sec.
> Aperture: f/8

RIGHT PLACE, RIGHT TIME ≫

Camera skills are important, but there's still no substitute for being in the right place at the right time to catch the light and conditions.

3 » DEPTH OF FIELD

Depth of field is a perfect illustration of the difference between what the camera sees and what the eye sees. The eye scans the world dynamically—whatever we're looking at, near or far, we normally see it in focus. Photographs often fail to match this; even if we've focused perfectly on the main subject, objects in front of or behind the subject may appear soft or blurred.

Sometimes this is welcome, as it makes the main subject stand out; sometimes it isn't. In landscape photography—where there usually is no single "subject"—the traditional approach is to try and keep everything in focus. In other words, we try to maximize depth of field. But this is a choice, not a fundamental law.

In practice, because the P7700 has a small sensor and the true focal length of the lens is short, it delivers lots of depth of field in most circumstances. The wide-angle setting (28mm-equivalent) gives

images with much greater depth of field than a 28mm lens on an SLR, focused at the same distance and using the same aperture setting. The same is true throughout the focal length range.

At 200mm, especially at wide apertures, SLR lenses can produce very shallow depth of field, with backgrounds becoming extremely blurred. The P7700's ability to do this is much more limited, even at the widest setting (at 200m this is f/4). However, depth of field also decreases as you focus closer, so you can still get nicely blurred backgrounds when shooting nearby subjects, like a flower or a head-and-shoulders portrait. At macro range (see Chapter 5, *page 186*), depth of field can become very slender indeed.

In sum, to increase depth of field, use the wide-angle end of the lens, use a small aperture (f/8), and shoot distant subjects. Of course, if you're shooting a fairly close subject you can still use a small aperture to increase depth of field. To reduce depth of field, the opposite applies. (Remember, aperture numbers are really fractions, so f/8 is a small aperture while f/2.8 is large.)

If you also have experience with SLR

TREE OF LIGHT «
With the lens at its longest setting and the subject quite close, the background is nicely soft. *ISO 200, 200mm, 1/250 sec., f/5.6.*

cameras, you'll know that their lenses can stop down to very small apertures—f/16, f/22, or in some cases even f/32. You might wonder why the P7700 can't do this; in fact, the smallest aperture you can set is f/8. The answer is that the P7700's lens is physically very much smaller than the equivalent on an SLR (which you'll appreciate when carrying it), and the physical size of the aperture is much smaller too. Don't forget that the true focal length (see below) of the lens is 6mm at its wide-angle setting. This means that at f/8 the effective diameter of the aperture is less than 1mm.

The smaller the physical aperture, the more it is susceptible to a phenomenon called diffraction, a spreading out of light rays which softens the image. With every lens, there's a trade-off: stopping down to smaller apertures increases depth of field but also increases diffraction, impairing peak sharpness.

VANTAGE POINT ≫
Here the aim was to have everything sharp: wide-angle lens, small aperture, focus point close to the camera. *ISO 200, 28mm, 1/320 sec., f/4.*

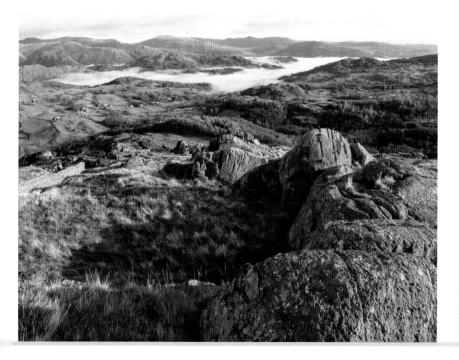

3 » FOCAL LENGTH

The ways in which focal length is described can be very confusing. Don't blame me, this is how the photographic industry has chosen to do things. When talking about SLR cameras, and lenses made for them, the industry normally uses the true focal length. For example, the "kit" lens often supplied with the D3200 DSLR is an 18–55mm.

However, when describing compact cameras like the P7700, as well as smartphones, the industry mostly uses the "35mm-equivalent" figure instead. This made sense in the early days, when digital compacts were competing directly with compacts that used 35mm film; you could assume that a "28mm" lens on the digital compact gave the same angle of view as a 28mm lens on a film camera.

Using "35mm-equivalent" figures is still helpful to a degree, as it allows us to compare different cameras with different sizes of sensor. The P7700's sensor is much smaller than that for a DSLR but larger than many other compacts and significantly larger than most smartphones. Where it all gets most confusing is in relation to DSLRs like the D3200. This has a sensor much larger than the P7700's but smaller than a 35mm film frame or a "full-frame" digital camera (like Nikon's D600). The true focal length of that lens for the D3200 is 18–55mm; its equivalent focal length is 27–82mm.

The true focal length of the P7700's lens is 6–42.8mm; its equivalent focal length is 28–200mm. Throughout this book, if we refer to focal length, unless it's prefixed "true", it's the equivalent figure we are using. And, of course, the best ways to get an idea of what the numbers really mean are (a) to look at some comparison pictures, like those opposite and (b) to use the camera yourself.

28mm

50mm

100mm

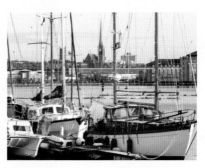

200mm

DIFFERENT FOCAL LENGTHS ⌃
This series of photographs was taken to
demonstrate the different focal lengths.
ISO 100, 1/160 sec., f/8.

3 » PERSPECTIVE

Perspective is about the visual relationship between objects at different distances. When distant objects appear to fade or become translucent due to haze or scattering of light, this is known as *atmospheric perspective. Optical perspective* refers to changes in apparent or relative size of objects at different distances.

It is distance that determines perspective. If you stay in one place and zoom the lens, you don't really change the perspective. However, different focal lengths can often be associated with different working distances and therefore they do become associated with changes in perspective. Using the wide-angle end of the lens range, at or near the 28mm setting, allows you to move closer to foreground objects, increasing their emphasis; this may be loosely called "wide-angle perspective". But it's the change in distance that changes the perspective. Similarly, shooting objects from a distance with a long (telephoto) focal length results in a compressed perspective, but the same perspective can be achieved at a wide-angle setting if the picture is cropped tightly.

A DIFFERENT PERSPECTIVE »

In this series of shots, the bollard and lifebelt frame the view each time, but *their* apparent shape, relationship to each other, and to the background all change. *ISO 100, 1/125 sec., f/8.*

Focal length 200mm, approximate distance 15m

Focal length 85mm, approximate distance 6m

Focal length 28mm, approximate distance 2m

» MOTION

There are many effective ways to portray movement in a still photograph, and they can reveal drama and grace which the naked eye (and, surprisingly often, the movie camera) miss. In determining how moving subjects appear in the image, the key control is the shutter speed.

Freezing the action

A fast-enough shutter speed will freeze almost any action: the P7700's maximum is 1/4000 second, which is usually more than adequate. You can often capture a sharp, frozen image with a much less extreme shutter speed; it depends on the speed of the subject, its distance from the camera, and whether it's moving across the frame or directly towards or away from you.

So there's no "correct" shutter speed, which underlines that 🏃 Sports mode is a pretty blunt instrument. For more precise control, Shutter-priority (S) mode is the obvious choice.

Review images on the monitor whenever possible, and if a faster shutter speed appears necessary, be prepared to up the ISO setting (see page 88). If you shoot certain sorts of action on a regular basis, you'll soon discover what works well.

And even if you were using 🏃, or another mode, the camera will record the shutter speed it used, so you can see the effect and directly relate it to the actual shutter speed.

> ### Tip
>
> *Frozen images work well for some subjects, less well for others. A frozen image of a car gives little sense of speed (it just looks like a parked car) but a frozen image of a runner can be superbly effective.*

FROZEN IN MOTION »
Both the lead runner's feet are off the ground in this shot. *ISO 400, 200mm, 1/640 sec., f/4.*

Panning

Panning is a classic technique for creating a sense of movement. By following the subject with the camera, it is recorded relatively sharply while the background becomes a streaky blur. The exact effect depends on speed and distance, so be ready to experiment. Start with relatively slow shutter speeds—perhaps 1/30 or 1/60 sec.—review the results, and be prepared to change. Faster settings diminish background blur but can keep the main subject sharper. 🏃 Sports mode is useless for this; it will invariably set too fast a speed; Shutter-priority is the best choice.

Panning is usually easiest with a longish lens setting, but when you're pinned behind a track-side barrier you don't always have a choice. Maintain a smooth panning motion and keep following through even after pressing the shutter.

This is tricky at first but does get easier with practice. Go to a big city marathon with thousands of runners and you can get a lot of practice in a very short time!

If you want to sharpen up the moving subject a bit more, with little effect on the background, try using the flash. Again, you can't do this in 🏃 Sports mode so stick with Shutter-priority.

> ### *Tip*
>
> *When shooting sports, wildlife, and so on, be careful when you use flash, as this can disturb the subject, and in some instances could be dangerous. Flash is banned at some sports events, and the action is often far beyond the reach of the flash anyway, so it serves no purpose, but annoys others.*

PANNING ⏬

This is a fairly extreme panning shot, handheld at 1/4 sec, but it's effective even though nothing is really sharp. *ISO 100, 105mm, 1/4 sec., f/5.6.*

PANNING WITH FLASH ⏬

A bit of flash sharpens up the figure while the background blur remains. *ISO 100, 50mm, 1/50 sec., f/8.*

Blur

Blur can also imply movement. It may be a necessity, because you just can't set a fast enough shutter speed, or it may be a creative choice, like the silky effect achieved by shooting waterfalls at exposures measured in seconds rather than fractions.

To ensure that only the moving elements are blurred, while the background remains sharp, secure the camera on a tripod or other solid support. This can give results which are almost the opposite of panning (see above). Of course, you can also try for a more impressionistic effect by handholding. Again, 🏃 Sports mode is not suitable and Shutter-priority is the obvious choice. And you might want to turn Vibration Reduction off.

Camera shake

Sometimes you'll move the camera intentionally; panning is the commonest example. Unintentional movement is another story. Camera shake can produce anything from marginal loss of sharpness to a hopeless mish-mash. The Vibration Reduction (VR) function is a big help, but it doesn't eliminate the need for careful handling. A solid camera support, such as a tripod (see page 218), is often the only solution—but turn off the VR if you're using one.

BLUR «
A slow shutter speed gives a very different impression of movement. *ISO 80, 33mm, 15 sec. (tripod), f/8.*

3 » COMPOSITION

Composition is a small word but a big subject. Composition, understood in its widest sense, is why some photos are perfectly exposed and focused but visually or emotionally dull, while others can be heart-stopping even if technically flawed. Composition is where to shoot from, where to aim the camera, how wide a view you want, what to include and what to leave out. All of these come before and stand above any so-called "rules of composition". Get these things right and you'll probably do pretty well without worrying about "rules". Ignore them and "rules" won't help you anyway.

The essence of composition is simple (though not necessarily easy). Taking a photograph means selecting some part of our boundless, three-dimensional world and turning it into a two-dimensional rectangle. Most of the time, apart from perhaps when we look out of a window,

we don't really see the world in rectangles. But we're very happy to confine it this way in photographs (not to mention the vast majority of paintings and drawings).

When we really think about photographs as rectangles, we should start to become very aware of edges—the edges of the screen and the edges of the picture itself. They define the picture; they're the key to what's included and what's left out. Our eyes and brains can "zoom in" selectively on the interesting bits of a scene, but the camera will happily and indiscriminately record all sorts of bits that we didn't even notice. This, all too often, produces pictures that seem cluttered or confusing. So it's important to see what the camera sees, not just what we want to see.

Looking through a traditional viewfinder is rather like looking through a window. When you use a screen instead, as the P7700 requires, the viewed image is more obviously two-dimensional—like a picture. It's possible that this might make it easier to see the whole image—the bits you're interested in and the bits you aren't.

Fortunately, the P7700's LCD screen is

THE WHOLE PICTURE «
There's no single "subject" here; every one of these mossy boughs is part of the whole.
ISO 80, 33mm, 0.8 sec. (tripod), f/8.

bright, crisp and clear. It also—unlike many traditional viewfinders, including the one in its P7100 predecessor—shows 100% of the picture area. Less happily, it can still be hard to see clearly in bright sunlight, though changing its position can help.

Framing the landscape

We mentioned that a key part of framing is what to include and what to leave out. With some shots this seems relatively simple—we know what the subject is. It could be a portrait shot of a person,

MAKING A SPLASH ⌃

The shining curves of the sea wall were very attractive, but I had little choice of shooting position as I wanted to stay in the shelter of a sculpture to protect myself and, more importantly, the camera, from the salt spray and the buffeting wind. And then each moment and each new wave created a different balance. Framing landscape shots means working with what you've got. *ISO 200, 175mm, 1/1600 sec. (tripod), f/8.*

an action shot of an athlete, a close-up of a flower. There are still decisions to be made—such as what sort of background you want—but at least we know what the photo is primarily about. Landscape photography is different.

Generally, landscapes don't offer up neat, pre-defined "subjects"; you have to start by deciding which bit of the landscape you want to photograph. There are no right and wrong ways to do this; a lot of it is about how you feel and how you react to the landscape. However, there are a few principles that can be helpful.

One of the most useful is to think about the foreground. After all, the foreground is where you're standing, and it's the start of your connection to the landscape. Foregrounds also show texture and detail, which imply sound, smell, and touch (and

sometimes even taste). Foregrounds are our friends—never more so than when the distant scene is hazy or flatly-lit and long-range shots just look dull.

Foregrounds can also help to convey depth and distance, and strengthen a sense of scale. Strong foregrounds are usually close foregrounds. Get close, and don't be afraid to exploit the third dimension: sit, kneel, crawl, climb.

To unite a strong foreground and a broad vista usually requires a wide-angle lens. The P7700's 28-mm equivalent zoom setting is wide—but not all that wide. Landscape photographers using SLR cameras may be shooting with lenses of 10, 12, or 14mm. However, the P7700 does have a trick up its sleeve: you can "stitch" multiple shots together to create a wider view. ⌧ Easy panorama lets you do this

Tip

Having stressed the importance of foregrounds, it's unhelpful that in Landscape mode (see page 48) the camera sets a wide aperture and uses infinity focusing; this can easily make foregrounds unsharp. To avoid this, use Manual or Aperture-priority, set the aperture to f/5.6 or f/8, and set AF-area mode to Manual so you can place the focus point closer to you.

VARIATIONS ⌄
Smaller details say much about the landscape but Landscape mode may not focus them sharply. *ISO 400, 55mm, 1/160 sec., f/8.*

in-camera, while ⊞ Panorama assist helps you align shots to make it easier combine them later.

Both Panorama modes can only produce long, narrow panoramas; they don't expand the view in *both* directions as a wider lens can. However, holding the camera in "portrait" orientation expands the vertical coverage of the frame and gives better foreground coverage. Combining two or three such shots in this way (still panning horizontally), you can match the coverage of a 21mm lens.

Tip

For the previous P7100 model, Nikon did produce a wide-angle converter, which expands the view to around 21mm-equivalent—a very significant gain. It's not yet clear whether one will be available for the P7700.

PANORAMA ⩔

Three photos taken in portrait format were stitched together to produce this image (below); compare the photo on the right, which is the widest view obtainable in a single shot (28mm). *ISO 100, 28mm, 1/60 sec., f/8.*

3 » LIGHT AND COLOR

Light is our raw material. Light is what photos are made from. However, just because light is the stuff of every image, we can easily take it for granted and "let the camera take care of it". This is a missed opportunity. Developing an awareness of light in all its variety is rewarding in itself, and it generally leads to better pictures.

Infinite variety

Light varies in many ways: intensity, color, direction, whether it's "hard" or "soft". All of these qualities have an impact in photographs. Intensity—whether it's bright or dim—is perhaps the most obvious, and we've looked at ways of responding to this with exposure, metering, and ISO settings.

Light comes from many sources, too, but by far the most important is the sun. Though the sun itself doesn't change much, its light can be radically changed by its passage through the atmosphere and by reflection from all manner of surfaces.

Another obvious source is flash. The light from the built-in flash is quite similar to direct sunlight in many ways, notably color and hardness, but its position is fixed and its range very limited (see Chapter 4, *page 172*).

Beyond sun and flash there are many other artificial light sources; their color can vary enormously—making the P7700's white balance controls invaluable—but

other qualities, like direction and contrast, can usually be understood by comparison with more familiar sunlight and flash.

Contrast and dynamic range

Contrast, dynamic range, tonal range: these terms all refer to the range of brightness between the brightest and darkest areas of a scene or subject. Just as our eyes adjust focus dynamically to create what seems like vast depth of field, they also adapt rapidly to let us see detail in both bright areas and deep shade. Even the best cameras often fall short by comparison when contrast is high, and their smaller sensors do mean that compact cameras like the P7700 can't manage high dynamic range as well as DSLRs do.

A typical example is when the sun shines from a clear sky; contrast may be even higher in deserts and at high altitude. In these "hard" lighting conditions bright highlights, like white clouds or snow, may appear completely blank and white, or the deepest shadows turn dead black, or even both together. This is called "clipping". Even without clipping, hard light produces hard-edged shadows, which aren't ideal for every subject—they tend to be unflattering in portraits, for example.

In overcast, "soft", lighting conditions, contrast is much lower. This is much easier

for the camera to handle, but can still produce great images of suitable subjects, such as portraits or flowers.

High contrast, with its risk of clipping, is challenging, but the P7700 offers several possible approaches. For closer subjects, like portraits, you can compensate by throwing some light back into the shadows, either using fill-in flash (*see page 173*) or a reflector. At longer range this is not an option, but Active D-Lighting or D-Lighting (*see pages 101 and 134*) can help. Shooting RAW images also gives a

chance of recovering highlight and/or shadow detail in post-processing. However, all these have their limits. Sometimes it's just not possible to capture the entire brightness range of a scene in a single exposure. The histogram display (*see page 87*) and the highlights display (*see page*

HIGH CONTRAST
There's some highlight clipping in the clouds, and shadow clipping in the foreground, but none of the areas affected are huge, so it's not too obtrusive. *ISO 400, 38mm, 1/1000 sec., f/8.*

94) help you to see when this is happening, and how much of the image is affected.

HDR (High dynamic range) mode (*see* under Backlighting, *page 61*) can handle high contrast by combining two separate images. For greater flexibility you can shoot several JPEG or RAW images and combine them manually in post-processing.

Direction

And then there's the question of where the light is coming from: in front, behind, or from the side? Frontal lighting is what you

get with on-camera flash, or with the sun behind you. It hits head-on, drenching everything with light, leaving few visible shadows. The resulting photos often look flat and uniform, but it can work well with images which rely on pure color, shape, or

SEEING THE LIGHT ⌄
Views looking down from above can appear flat, but not when there's strongly-angled sidelight like this. There's extra contrast in the difference between the warm light of the low sun and the cool tones of the shadows. *ISO 100, 66mm, 1/15 sec. (tripod), f/8.*

pattern. True frontal lighting rarely creates extremes of contrast, so exposure is usually straightforward.

Sidelighting is more complex and usually more interesting, with shadows defining forms and textures. It's terrific for landscapes, and many other subjects, but often goes hand in hand with high contrast.

Backlighting can give striking and beautiful results, but handle with care. Translucent materials like foliage and fabric can glow beautifully when backlit, but more solid subjects can easily appear as mere silhouettes. Sometimes this is ideal: bare trees can look fantastic against a colorful sky. When you don't want a silhouette effect, which you usually wouldn't in a portrait, a reflector or fill-in flash can help: it's what Backlighting mode (*see page 61*) is designed for.

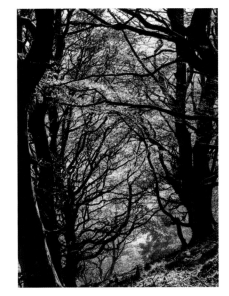

BURNING BRANCHES ⌃
Backlighting makes the foliage glow a wonderful golden color. *ISO 200, 75mm, 1/100 sec., f/8.*

Color

Light comes in many colors, but most of the time we barely notice. Cameras, however, are more observant. In general, the P7700's Auto White Balance will take account of changing light and keep colors looking pretty natural, but there are times when it may stumble (especially under artificial light). There are also times we don't want to "correct" colors at all; for example, when shooting a landscape in the warm golden light of a low sun. If White Balance is set to **Auto** (as it is in 🖼

Landscape mode), the P7700 may give a more neutral result than we really want. Instead, try shooting in Aperture-priority with White Balance set to **Direct sunlight**. (And shoot RAW; this gives you more room for further tweaking on the computer.)

There are still more ways in which what the camera sees doesn't match what the eye sees. Some of these arise from the fact that camera lenses are very different from the human eye.

Flare

Lens flare results from stray light bouncing around within the lens. It usually occurs when shooting towards the sun, whether the sun is actually in frame or just outside. It may produce a string of colored blobs, apparently radiating from the sun, or a more general veiling effect. You'll usually get an indication from the LCD screen, but of course bright conditions make it harder to see the screen clearly, so check again

on playback. If the sun's actually in frame, you can sometimes mask it, perhaps behind a tree. If it's not in shot, try to shield the lens; you can use a piece of card, a map, or your hand. This is easiest with the camera on a tripod; otherwise it requires one-handed shooting (or a helper). Check

FLARE DEAL **«**
Flare is all too evident in the first shot (above), but was eliminated simply by moving half a pace to one side so the sun was masked by a tree. *ISO 200, 92mm, 1/30 sec., f/8.*

playback carefully. Watch out for that map, card, or hand creeping into shot at the edge of the screen.

Distortion

Distortion means that straight lines appear in the image as curves. When straight lines bow outwards, it's called barrel distortion; when they bend inwards it's pincushion distortion. Because the way its lens behaves is known, the P7700 can correct this automatically, but it needs a visit to the Shooting menu (Distortion control, *see page 101*) to enable this. It only applies to JPEG images; RAW images can be adjusted later using software like Nikon Capture NX2 or Adobe Lightroom.

Distortion generally goes unnoticed when shooting natural subjects with no straight lines, but it can still rear its ugly head when a level horizon appears in a

> ### *Tip*
>
> *Distortion control does crop the image slightly, so leave it Off when shooting RAW, or when your subjects don't have any straight lines to worry about.*

landscape or seascape, especially near top or bottom of the frame.

Aberration

Chromatic aberration occurs when light of different colors is focused in slightly different planes, appearing as colored fringing on edges when images are examined closely. It's most likely to be noticed in high-contrast shots. It can be corrected in post-processing with suitable software; as usual, there's more room for maneuver with RAW images.

BOWED BUILDING «
Distortion makes the building appear bow-fronted; it's especially obvious in the gutter and roofline. *ISO 100, 28mm, 1/250 sec., f/8.*

Noise

Image noise is created by random variations in the amount of light recorded by each pixel, and appears as speckles of varying brightness or color. It's most conspicuous in areas that should have an even tone, and normally worst in darker areas of the image. Cramming more megapixels onto a sensor increases the incidence of visible noise, so it's good that the P7700 has a relatively modest 12.2 megapixels. However, the P7700 is not immune to noise, and certainly can't match DSLR cameras with their much larger sensors. There's no escaping the fact that noise is evident when shooting at higher ISO ratings.

Noise reduction is applied to JPEG images as part of in-camera processing (*see page 100*); for RAW files it's applied during post-processing.

To minimize noise, shoot at the lowest possible ISO rating and avoid underexposure. This often requires the use of a tripod.

Clipping

Clipping occurs when highlights and/or shadows are recorded without detail, turning shadows an empty black and highlights a blank white. Clipping is indicated by a "spike" at either extreme of the histogram display, and also by a flashing warning in playback (*see page 94*). For some ways to limit clipping, *see pages 83 and 101*.

Artefacts and aliasing

Normally we aren't really aware that a digital image is composed of individual pixels, but small clumps of pixels can sometimes become apparent as "artefacts" of various kinds. *Aliasing* is most evident on diagonal or curved lines, giving them a jagged or stepped appearance. *Moiré* or *maze artefacts* can occur when there's interference between areas of fine pattern in the subject and the grid pattern of the

ESCALATOR ⌄
Noise is very evident in this enlarged section of an image taken at ISO 3200—but did you notice it in the original *on page 89.*

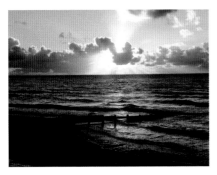 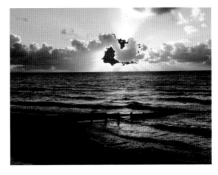

SEEING RED ⤬

Clipping was inevitable with such extremes of contrast (left). It's slightly surprising that there's none in the shadows. The right-hand image shows the extent of clipped highlights (in red). *ISO 400, 58mm, 1640 sec., f/8.*

sensor itself. This often takes the form of aurora-like swirls or fringes of color.

To try and forestall these issues, most digital cameras employ a low-pass filter in front of the sensor. Crudely put, this works by blurring the image slightly; while effective in removing artefacts, images need resharpening either in-camera or in post-processing (see below).

JPEG artefacts look much like aliasing, but are created when JPEG images are compressed, in-camera or on the computer. Minimize them using the Fine setting for images to be printed or viewed at large sizes. Repeatedly opening and re-saving JPEG images on the computer multiplies the effect of JPEG artefacts.

Sharpening images

Because of the low-pass filter, all digital camera images require a degree of sharpening. However, too much sharpening can produce its own artefacts, a common form being halos along distinct edges.

JPEG images are sharpened during in-camera processing. Sharpening settings are accessed through Nikon Picture Controls (*see page 40*), and are therefore predetermined when shooting in Auto and Scene modes. In User-control modes, you can change sharpening levels; however, be wary about increased sharpening unless images are solely destined for screen use. It's easy to add sharpening later, when you can judge the effect at 100% magnification on the computer screen; but it's virtually impossible to eliminate existing artefacts created by oversharpening.

With RAW images, sharpening takes place on the computer.

If anyone suggests that a compact camera isn't suited to the slow, almost meditative approach required for landscape photography, I might offer this image as a counter-argument. A compact does have its limitations for some shots, notably in dynamic range, but it did just fine here. My approach was exactly the same as it would have been had I been using a DSLR. The most important factor was finding the right position and shooting height to see lots of the golden, sunlit foliage in reflection, but still keep enough of the blue sky for contrast.

> **Settings**
> › Focal length: 74mm
> › Sensitivity: ISO 200
> › Shutter speed: 1/20 sec.
> › Aperture: f/8
> › Support: tripod

NEAR SCORTON, LANCASHIRE, UK

» RUNNER

Even at its 200mm setting, and widest aperture, the P7700's lens doesn't give the really shallow depth of field that a DSLR lens does at similar settings, and therefore subjects like these runners stand out from the background far less clearly. To try and compensate for this, I looked for a spot where the background wasn't too distracting. Shooting as the runner entered a patch of sunlight, with shadows behind, helped isolate them from the background too. I used Manual Focus, prefocusing on the road surface in the sunlit area before the first runner arrived; this avoided any delays caused by the camera trying to refocus. Every single shot (and I took a lot!) was pin-sharp. I very much doubt I'd have scored 100% if I'd been using autofocus.

Settings
> Focal length: 200mm
> Sensitivity: ISO 400
> Shutter speed: 1/400 sec.
> Aperture: f/4

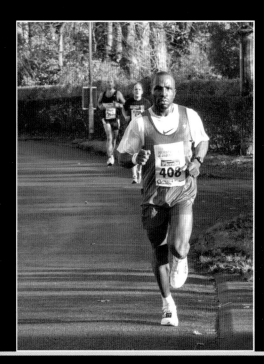

**PRESTON GUILD 10-MILER,
NEAR LONGTON, LANCASHIRE, UK**

This was one of those days when everything comes together: high tide, a strong onshore wind, and fantastic light. There are several shots from the same afternoon in this book. This was an attempt to do something slightly different. I set the tripod low and as close to the ironwork as I could, to give prominence to the fabulous colors and patterns. At a focal length of 28mm and aperture of f/8 there's lots of depth of field, but I focused carefully all the same. Incidentally, it says something for the power of the sea that those pebbles between the timbers are firmly wedged!

Settings
> Focal length: 28mm
> Sensitivity: ISO 400
> Shutter speed: 1/320 sec.
> Aperture: f/8
> Support: tripod

ROSSALL BEACH, LANCASHIRE, UK

» ON HIGHER GROUND

Some shots are carefully planned and pre-visualized and some you just stumble across. This was more or less in the second category, but having seen the patterns of the stream and its old channels from the ridge, I had to descend some way to get a more complete view.

It wasn't until I put the two shots together in the final stages of preparing this book that I saw the similarities between the patterns here and the figuring in the timber on the previous page.

Settings
> Focal length: 155mm
> Sensitivity: ISO 125
> Shutter speed: 1/500 sec.
> Aperture: f/8

HOWGILL FELLS, CUMBRIA, UK

Chapter 4
FLASH

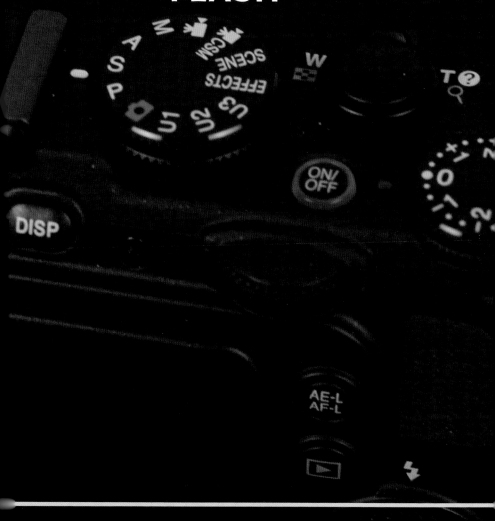

4 FLASH

Flash can be immensely useful to the photographer, but flash photography is also, all too often, shrouded in confusion and frustration, usually because the fundamental principles are unclear.

» PRINCIPLES

All flashguns are small. All flashguns are weak. These two facts are key to understanding flash photography. They are especially true for built-in units like that on the P7700 and most other compact cameras, which are smaller and weaker than those on DSLRs. Accessory flashguns, like Nikon's Speedlights, are bigger and more powerful—but they are still small and weak.

Because it's small, the flash produces very hard light. It's similar to direct sunlight, but even the strongest sunlight is slightly softened by scattering and reflection; we can sometimes soften the flash, too.

Its weakness is even more fundamental. All flashguns have a limited range, and compact camera flash is more limited than most. Flash can only be used on nearby subjects. It's no good for illuminating the stage at a stadium rock concert—and they have massive banks of lights for that, so why bother?

Built-in flash units raise a third issue, too, namely their fixed position close to the lens; this makes the light one-dimensional—and the same for every shot. It's as boring as lighting can get.

For all these reasons, and more, flash is not the answer to every low-light shot. Understanding its limitations helps us understand when to seek alternatives, as well as when and how we can use flash effectively.

» PAINTING WITH LIGHT

This is an unusual, but often very effective technique, which you can try with any flashgun, even the cheapest, as long as it can be triggered manually. By firing multiple flashes at the subject, you can light it from different directions without the light becoming flat. It requires trial and error, but that's part of the fun. The basic steps are:

1) Ensure that neither camera nor subject can move during the exposure.

2) Use Manual mode. Set a long shutter speed, e.g. 20 seconds. Set the aperture to f/8.

3) Turn out the lights. It helps to have just enough background light to see what you are doing, but no more.

4) Trip the shutter and then fire the flash at the subject from different directions (without aiming directly into the lens).

5) Review the result and start again! For example, if results are too bright, use fewer flashes, a lower ISO, a smaller aperture, fire from further away, or a combination. If the flash has a variable power setting this could be turned down.

If you don't have a flashgun you can also try light-painting with a small torch or LED light.

Settings
› Focal length: 66mm
› Sensitivity: ISO 200
› Shutter speed: 10 sec.
› Aperture: f/8

» BUILT-IN FLASH

The flash popup button

The P7700's built-in flash, like all such units, is small, low-powered, and fixed in position close to the lens axis. As well as limiting working range, these factors mean the flash produces a flat and harsh light which is unpleasant for, say, portraits. It may be better than nothing, but it only really comes into its own when used for fill-in light.

It can also be used as a "Commander" to trigger and regulate an external Speedlight (*see page 179*).

Operating the built-in flash

The flash does not pop up by itself; it is always necessary to press the button to raise it. However there are some modes (e.g. ☺ Night portrait) in which the camera will display a message telling you to raise the flash, and won't take a picture without it. In other Scene modes, the flash is not available; you can press the button and it will pop up but it will not fire. See the chart on *page 45*. Of course, P, S, A, and M modes give you complete freedom whether or not to use the built-in flash.

1) Push 𝟇 downwards and the flash will pop up and begin charging.

2) Press ▲ to call up a list of available flash modes. Select the desired mode and press **OK** to make it active. (See below for explanation of flash modes.)

3) Take the photo in the normal way.

4) Review the image. If results are not how you wanted, consider a different flash mode or flash compensation (*see page 173 and 177*).

5) When finished, lower the built-in flash, pressing gently down until it clicks into place.

» FLASH MODES

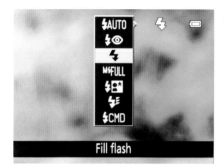

Flash mode setting options on screen

› ⚡ Fill-in flash

A key application for flash is for "fill" light, giving a lift to dark shadows like those cast by direct sunlight. It's certainly one of the best uses for small, low-powered, built-in flash (many would say it's the only thing it's really good for). Therefore we are promoting it to first place in the list of flash modes.

When Fill-in flash is active, the built-in flash will fire for every shot (provided the flash is raised, of course), but the camera will calculate the flash output on the basis that it's for fill light—unlike ⚡AUTO Auto and ⚡⊙ Red-eye reduction, where the camera calculates flash output to fully light the subject.

Fill flash doesn't need to illuminate the shadows fully, only to lighten them a little. This means the flash can be used at a smaller aperture, or greater distance, than

FILL-IN FLASH ⚙
The background exposure is the same for both shots, but without flash (right) the underside of the boat is virtually black. *ISO 100, 28mm, 1/10 sec., f/8.*

when it's the main light (averaging around two stops smaller, or four times the distance).

⚡ Slow sync and ⚡ Rear-curtain sync (see below) are specialized variants of fill-in flash.

› ⚡AUTO Auto flash

This is the default setting in many modes. The flash does not always fire; it won't operate if the camera thinks there is enough light around for a decent shot without flash. However, when it does fire the flash, the camera calculates flash output on the basis that it's the main light. In other words it tries to fully light the subject, though it can only do so successfully if the subject is in range (see the next page).

› ⚡◉ Auto with red-eye reduction

In most respects, this mode is the same as ⚡AUTO. However, red-eye reduction works by firing several pre-flashes at the subject just before the exposure, causing the subject's pupils to contract. This creates a very noticeable delay, which kills spontaneity (little chance of a "candid" shot here). The delay also makes it tricky to shoot moving subjects. Most of the time, it's far better to remove red-eye in post-processing; most software packages have a facility to do this. Better still, use a separate flash, away from

the lens axis, or no flash at all, perhaps shooting at a high ISO rating. The camera manual calls this "best choice for portraits". It almost never is.

› ⚡ Slow sync

Slow sync (short for synchronization) is a specialized variant of ⚡ Fill-in flash. It allows longer shutter speeds to be used, so that backgrounds can be captured even in low ambient light. Movement of the subject or camera (or even both) can result in a partly blurred image created by the ambient light, combined with a sharp image where the subject is lit by the flash. This is often used for creative effect.

⚡ Night portrait mode uses a form of slow-sync flash, combined with red-eye reduction.

› ⚡ Rear-curtain sync

"Rear curtain" is a term that really applies to DSLRs (whose shutter mechanisms operate in a different way to that on the P7700). What it means in practical terms is that the flash is fired not at the first available moment (as in ⚡ Slow sync) but at the last possible instant. At faster shutter speeds there's no detectable difference between slow sync and rear-curtain sync, but at longer speeds the difference can become obvious.

The limited range and power of the built-in flash severely limits the use of slow/rear-curtain sync for creative action photography: using an accessory Speedlight is all but essential.

Rear-curtain sync makes sense when photographing moving subjects because any image of the subject created by the ambient light then appears behind the sharp flash image. This generally looks more natural than having the ambient image extend ahead of the direction of movement. ⚡ Rear-curtain sync can only be selected when using P, S, A, and M Shooting modes.

› M⚡ Manual

You can control the flash output manually, selecting from FULL, ½, ¼, ⅛, ¹⁄₁₆, ¹⁄₃₂ and ¹⁄₆₄ power. If an SB-400 Speedlight is attached you can also dial it down to ¹⁄₁₂₈.

› Flash range

The table below details the approximate range of the built-in flash for selected distances, apertures, and ISO settings. These figures are based on the published Guide Number and confirmed by practical tests. There's no need to memorize them, but they should help to give a sense of the very limited range within which the flash can be used. A quick test shot will confirm if a subject is within range in any given situation. The maximum range is shorter when the lens is zoomed to longer focal lengths, because the maximum aperture is also smaller (f/4 at 200mm).

| | ISO setting | | | | | | Maximum Range | |
	100	200	400	800	1600	3200	meters	feet
Aperture			2.8	4	5.6	8	5	16' 5"
		2.8	4	5.6	8		3.5	11' 6"
	2.8	4	5.6	8			2.5	8' 2"
	4	5.6	8				1.75	5' 9"
	5.6	8					1.25	4' 1"
	8						0.88	2' 10"

4 » GUIDE NUMBERS

The Guide Number (GN) is a measure of the power of a flash. In the past, photographers used GNs constantly to calculate flash exposures and working range. With modern flash metering, such computations are rarely needed, but the GN does help us compare different flashguns. For instance, the GN for the built-in flash is around 7 (meters, ISO 100); for the Nikon SB-900 it is 34, indicating around five times the power. This allows shooting at five times the distance, at a lower ISO, or with a smaller aperture.

BOW LIGHT ⌄
This clearly shows the limited range of the built-in flash, which only really lights the bows of the boat, even with the lens at its widest aperture. *ISO 100, 28mm, 1/125 sec., f/2.*

» FLASH EXPOSURE

Whether the shutter speed is 1/200 second, ½ second or 20 seconds, the flash normally fires just once during this time and therefore delivers the same amount of light to the subject. If there were no other light, the subject would look the same whatever shutter speed was used. Shutter speed only becomes relevant when there is other light around, often called ambient light. Set a longer shutter speed and the effect of the flash won't change but the effect of the ambient light will (the background becomes brighter).

Aperture, however, is relevant to both flash exposure and ambient exposure. The camera's flash metering takes this into account, but it is useful to understand this distinction for a clearer sense of what's going on, especially with slow-sync shots. Of course, in most modes, the camera regulates shutter speed and aperture automatically, but in Shutter-priority, Aperture-priority and Manual it's down to you.

› Flash compensation

Although the P7700 has accurate flash metering, you may still want to adjust flash output, perhaps for creative effect. Immediate playback makes it easy to assess the effect of the flash level and judge whether compensation is needed.

Unfortunately setting flash compensation is not quite as quick and easy as regular exposure compensation. It's done through the **Flash exp. comp** item in the Shooting menu (you can also add this to My Menu).

Compensation can be set from −2 Ev to +2 Ev in increments of ⅓ Ev. Positive compensation will brighten areas lit by the flash, while leaving ambient-lit areas unaffected. However, if the subject is already at the limit of flash range, positive compensation can't make it any brighter.

Negative compensation reduces the brightness of flash-lit areas, again leaving other areas unaffected. After use, reset flash compensation to zero.

Flash compensation is only available in P, S, A, and M modes. If you're shooting in one of the other modes and the flash is over-lighting the subject, your only real options are switching to one of the User-control modes or, possibly, moving further away from the subject. Similarly, if the subject appears under-lit, switch mode or

+1 Ev

move closer. You may have to do this anyway—being out of range is probably the commonest reason why flash subjects appear too dark.

BEAR EXPOSURE « ≈

These three shots were taken with flash compensation. Note that the background exposure is unaffected. Personally I think the ideal would be between 0 and −1. *ISO 200, 92mm, 1/30 sec., f/4.*

0 Ev

−1 Ev

» EXTERNAL FLASHGUNS

The built-in flash has severe limitations, especially for portrait and close-up photography—just the areas where flash could be most useful. Its low power is an issue, but its lack of flexibility is even more limiting. Both can be tackled by using an accessory flashgun (Nikon calls them Speedlights).

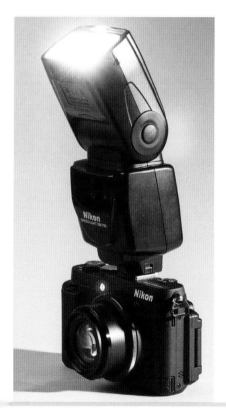

There are currently three Speedlight models: see the table on the next page. The SB-910 is very impressive—but it weighs slightly more than a P7700, and doesn't cost much less. The cheaper SB-400 will make the camera feel less top-heavy. Earlier models like the SB-900, SB-800, and SB-600 can also be used.

The P7700 also has the ability to control these units wirelessly. This is a really significant advance over previous Coolpix models.

Units like the SB-910 can also be used as a "Commander" to control an even more complex array of Speedlights—though if you're going to all that trouble and expense you're probably going to use a DSLR.

Mounting an external Speedlight

1) Check that camera and Speedlight are both switched OFF, and that the pop-up flash is down. Remove the hotshoe cover.

2) Slide the foot of the Speedlight into the camera's hotshoe. If it does not slide easily, check whether the locking lever on the Speedlight is in the locked position.

A P7700 almost dwarfed by an SB-700 Speedlight

3) Turn the lock lever at the base of the Speedlight to secure it in position.

4) Switch ON the camera and the Speedlight. A 🔲 icon appears on the camera's LCD screen and you can select flash modes in the usual way (the available selection may differ depending on the Speedlight).

> ## Bounce flash

The fixed position of the built-in flash is its greatest weakness. Nikon's Speedlights have tilting heads, which allow light to be bounced off ceilings or reflectors. Bouncing the flash light off a suitable surface spreads the light, softening hard-edged shadows, and changes its direction, producing far more natural and appealing results. Bounce surfaces absorb some of

NIKON SB-400 ⌃
This simple and (relatively) inexpensive Speedlight is a good partner for the P7700. Mounted in the hotshoe it doesn't make the combination hopelessly top-heavy. It can also be fired wirelessly.

the light, and the light also has to travel further to reach the subject; flash metering will automatically adjust for this, but the effective range is reduced. However, Nikon's Speedlights have much more power than the built-in unit.

	SB-910	SB-700	SB-400
Guide Number for ISO 100, meters	34	28	21
Tilt/swivel	Yes	Yes	Tilt only
Dimensions (width x height x depth)	3 x 5.7 x 4.5in./ 78.5 x 145 x 113mm	2.8 x 5.0 x 4.1in./ 71 x 126 x 104.5mm	2.6 x 2.2 x 3.2in./ 66 x 56.5 x 80mm
Weight (without batteries)	14.8 oz/420g	12.7 oz/360g	4.5 oz/127g
Use as Commander?	Yes	Yes	No
Included accessories	Diffuser, stand, color filters, case	Diffuser, stand, color filters	

› Off-camera flash

Taking the flash off the camera gives you complete control over the direction of its light. To maintain full metering and control of an external flashgun you can physically connect it to the camera, using a flash cord (also known as a sync lead). Dedicated cords like Nikon's SC-28 allow full communication between camera and Speedlight. The SC-28 extends up to 5ft (1.5m). Alternatively, the P7700 can control a Speedlight wirelessly (see below).

Whether you control it wirelessly or not, off-camera flash can be fired from any angle on the subject, but it remains a small and hard-edged light source. You can reduce the contrast by using a reflector on the opposite side of the subject—for example, by sitting your portrait subject close to a white wall. For small subjects you can just use a white card. Dedicated photographic reflectors and diffusers are also available.

Tip

If you're using an external flashgun other than a compatible Nikon Speedlight, a sync lead is the only way to trigger it.

› Wireless flash

Nikon's Creative Lighting System includes the ability to regulate the light from multiple Speedlights through a wireless system. The SB-900 and SB-700 Speedlights can be used as the "Commander" for a wireless setup. There's also a stand-alone Commander, the SU-800. And, for the first time on a Coolpix camera, the P7700 can operate as the Commander unit, though it can't run such complex setups as the other units. It can only do this when it's in P, S, A, or M mode.

› Using the P7700 as Commander

Before starting, make sure that the external Speedlight is set to Group A and its channel setting is 3; see the Manual for the Speedlight you are using for details.

1) In the Shooting menu, select **Commander Mode**.

2) Pick a flash mode from the list of options: **Standard flash**; **Slow sync**; **Rear-curtain sync**; **Red-eye reduction**. *See page 173* for explanations of these modes.

3) Pick a flash control mode; this determines how the flash brightness level is regulated. The options are TTL, in which case the flash output is regulated by the camera's metering system, and **Manual**, in which you can set flash values from **Full** to **1/128**.

With TTL flash control, if you are using matrix or center-weighted metering, background brightness will also be taken into account. Flash compensation can be applied in the normal way (*see page 177*), except that you can set values from −3 Ev to +3 Ev.

(*see page 177*)

> ### *Tip*
>
> *If the external Speedlight is well away from the lens axis, red-eye is unlikely to be a problem. Red-eye reduction mode will still cause a shooting delay, however, so is best avoided.*

STILL LIFE ❯❯
The first image (left) was taken using the built-in flash, which makes the bananas look oddly flat, despite an ugly shadow. The second (middle) uses indirect flash from the left. The third (right) uses bounce flash, giving softer, more even light, but retaining a 3D quality. *ISO 200, 85mm, f/3.2.*

LEAF LIGHTNG »
Using a sync lead enabled me to fire a Speedlight from the far side of the leaf. The backlighting emphasizes the vein structures. I used a 50mm focal length which is usually best for close-up work with the P7700. *ISO 800, 50mm, f/5.6.*

COOLPIX P7700

Chapter 5
CLOSE-UP

5 CLOSE-UP

The P7700 can focus less than 1in. (2cm) from the front of the lens, giving it real potential for exploring a whole new world that lies, sometimes literally, right under your nose.

» FOCUS DISTANCE

To use the camera's closest focusing abilities, set focus mode to 🌷 **Macro close up** (in 🌷 **Close up** mode this applies automatically). With the lens at wide-angle (28mm) setting, the 🌷 icon in the display turns green, but if you zoom out it turns white somewhere just beyond the 50mm mark.

Nikon states that the closest focusing distance is 0.8in. (2cm) from the lens. In practice I've found it's a fraction closer, but only at the 28mm zoom setting; it roughly doubles at 50mm. If you zoom out beyond 50mm, as the green indicator disappears, the focus range also abruptly gets longer. At 200mm setting the closest you can focus is about 15.8in. (40cm) from the front of the lens. The table shows the minimum focusing distances for various zoom settings, from my own practical tests.

TEXTURES «
Close-up subjects are everywhere, and close-up photography makes us pay attention to them.
ISO 80, 28mm, 1/250 sec., f/2.

MAXIMUM MAGNIFICATION AT A RANGE OF FOCAL LENGTHS

If you look at the images of the watch, you can see that apparent magnification at 50mm is nearly, but not quite, as large as at 28mm. However, the subject is also more than twice as far from the front of the lens. This makes it much easier to light it properly (you can see that the shot taken at 28mm is shadowy). In subjects with straight lines, you'll also see much less distortion at 50mm. The clear conclusion is that, unless you really need that last extra scrap of magnification, 50mm is a much more practical focal length for close-up shooting than 28mm. When you need to work at longer range (e.g. with living subjects), 200mm is the best option.

Lens focal length setting	Minimum distance (measured from front of lens)
28mm	0.6in. (1.6cm)
35mm	1.2in. (3cm)
50mm	1.7in. (4.2cm)
85mm	10.6in. (27cm)
105mm	15in. (38cm)
135mm	16.5in. (42cm)
200mm	16.5in. (42cm)

» DEPTH OF FIELD

As you move closer to the subject, depth of field (see page 144) becomes narrower; at 0.8in. (2cm) from the subject it's very slim indeed. Even on a fairly flat subject, like the watch, the face itself may be sharp but the outer bezel isn't. Merely focusing on "the subject" is no longer good enough. You must decide which part of the subject—like a single petal on a flower—should be the point of sharp focus.

Also, with such a narrow depth of field, the slightest movement of either subject or camera can ruin the focus. Handholding is unreliable at best, so you'll usually need a tripod or other solid camera support. Sometimes you'll also need to prevent the subject from moving (within ethical limits, of course).

The other focus mode option is ✿ **Close range only**. This, as the name suggests, limits the camera to focusing on close subjects. This can stop the camera

"hunting" for focus through a wide range, which can be a time-consuming process; it's particularly useful when focusing on subjects with a distant background behind. However, it can slow you down when you want to make a move quickly from a close-up to shooting, say, a landscape image.

MOSS SHOT ⌄
There's very slender depth of field in this oblique-angled shot of these tiny plants.
ISO 80, 42mm, 1/500 sec., f/2.5.

THE IMPROVISED STUDIO ⏏

The sum total of specialized photographic gear required to get this shot was: camera; tripod; Speedlight; sync lead—and I could probably have managed without the sync lead and used wireless flash control (*see page 181*). Everything else was improvised. The backdrop is an old camping mat and I used a couple of bits of white card on the right as reflectors. The berries, backdrop and reflectors were all propped or clamped to bits of furniture in my kitchen.

I used the 50mm focal length because this is usually the most practical for macro work (*see page 186*), and focused manually at minimum distance, shifting the camera until it was as close as possible to the berries.

5 » MACRO LIGHTING

When you get really close to the subject, getting enough light onto it can become tricky. The camera—and you yourself—may be casting a shadow, and when the subject's fixed in place, and the working distance is only a couple of inches, there may be very little you can do to rectify it. As we've observed, this is easier when shooting at 50mm focal length than at 28mm, but it can still be tricky.

The built-in flash is not the answer. Apart from the usual problem that its light is ugly, at really close range it simply can't light the whole subject; the lens itself casts a shadow. Even if you pull back a bit the light is still uneven. The official recommended minimum distance for using the flash is around 20in. (50cm).

In consequence, we will very often need to find some other way to get more light onto our subject. Something as simple as a flexible desk lamp will often serve. If there's a separate flashgun available this can also be used, connecting with a sync lead (*see page 181*), or (in the case of a compatible Nikon Speedlight) controlling it wirelessly (*see page 181*).

Both of these will, of course, give strong light from one side, probably creating high contrast and bold shadows. One way to balance the lighting more evenly is to place a reflector on the opposite side of the subject. This can be as simple as a piece of white card; the closer it is to the subject, the stronger the effect. If this all starts to sound as if you need three hands... the camera is on a tripod, isn't it?

There are many specialist macro lighting units, some using flash and some using LEDs; almost all of them are intended for use with DSLR cameras but sometimes they can be adapted.

One that I find handy (and inexpensive)

> ## Tip
>
> *As far as lighting goes, some of the easiest subjects to shoot at ultra-close range are translucent ones with light from behind, like backlit leaves.*

WORST-CASE SCENARIO　　　　　　**«**
At 28mm focal length and minimum distance, the flash illuminates less than half the subject and there's serious glare in other areas.

is the Sunpak LED Macro Ring Light. Its continuous output allows you to preview the image in a way you can't do with flash. However, its low power limits it to very close, and usually static, subjects. Unfortunately the Sunpak does not come with an adapter for the 40.5mm filter thread of the P7700; however, with the camera on a tripod, it's easy just to hold it in place around the lens.

MACRO FLASH ⌄

To reveal the textures of these tiny fossils, I fired a Nikon SB-700 from an acute angle on the left. The flash was linked to the camera by a remote cord. A reflector on the right balanced the lighting. *ISO 800, 28mm, 1/60 sec., f/7.1.*

RED-HOT PEPPER ⌃

This shot was taken with the Sunpak Ring Light. There's good illumination on the pepper, but observe how quickly the light falls off on the background. This can make it easy to isolate your subject. *ISO 80, 28mm, 1/15 sec., f/8.*

5 » CREATIVE MACRO PHOTOGRAPHY

Pedants may say that the P7700's close-up abilities don't properly qualify as "macro." Macro photography strictly means photography of objects at life-size or larger, implying a reproduction ratio of at least 1:1. This would mean being able to fill the frame with an object the same size as the imaging sensor—which measures 7.5 x 5.5 mm. Of course when the image is printed, or viewed on a screen, it may appear many times larger, but that's another story. In fact the smallest object you can focus sharply is about 1.6 x 1.2in. (4 x 3cm). Though this is not true macro, it actually compares pretty well with what most DSLR cameras can do, at least without using a special macro lens. However, it's hard to get an exact

KEY SUBJECT ⌄
Another example of the smallest size subject that you can shoot with the P7700. Observe the distortion too! *ISO 800, 28mm, 1/80 sec., f/8.*

measurement because there's very pronounced barrel distortion (*see page 161*) when the lens is at 28mm zoom and minimum focus. As we've seen, at 50mm the magnification is just a little less, but distortion is very much reduced.

This critical size gives you an immediate sense of the subjects you can tackle with the P7700. The dimensions of 1.6 x 1.2in. (4 x 3cm) equal just under a quarter of a credit card, for example. The full credit card is also a pretty useful yardstick; for subjects significantly larger than this there's no obvious advantage in using 🌼 Close-up mode or 🌷 Macro close-up focusing.

So what kinds of subjects might fit into this range? Flowers are a favorite close-up subject: many flowers, whether wild, garden, or house-plants, are substantially larger than 1.6 x 1.2in. (4 x 3cm) and you'll often be able to photograph the intricate and beautiful details of their internal structure. However, when you try this outdoors, you'll soon find that even the slightest breeze can cause your subject to sway frustratingly in and out of focus. You'll soon appreciate how rare a truly calm day is.

1.6 x 1.2in. (4 x 3cm) is also in the ball-park for the wing of a butterfly, but there are a few practical difficulties in getting close enough; butterflies aren't noted for sitting still anyway, let alone when some giant is thrusting a camera at them. You're more likely to get a reasonable shot with the lens set to 200mm, but even at a distance of 20in. (50cm) or so, butterflies tend to be several moves ahead of you. The same is true of most of the animal kingdom, but your chances improve with slower-moving creatures: what about snails, for instance?

Non-living subjects are often less mobile, and still offer fascinating possibilities. And that's one of the joys of close-up photography: it makes you look at familar objects in a fresh light.

Tip

One way to be sure you're focusing at the closest possible distance is to reset the focus to Manual, then set the focus distance to its minimum. Now move the camera and/or subject until the image is sharp. For static subjects, at least, this can be quicker and more reliable because you've eliminated one of the variables.

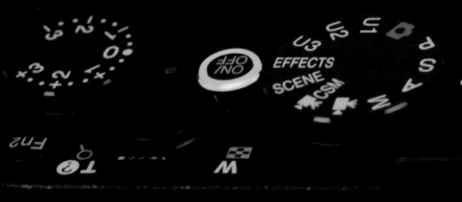

Chapter 6
MOVIES

6 MOVIES

The ability to record moving images is now taken for granted on quality compact cameras, and is a handy adjunct to the P7700's polished performance in still photography.

» QUALITY, FORMAT AND CARDS

The P7700 can shoot Full HD (High Definition) quality with a frame size of 1920 x 1080 pixels. These can naturally be played through an HD TV as well as through a computer. In addition, you can also record your clips at resolutions of 1280 x 720 pixels (720p) and 640 x 480 (VGA). VGA is suitable for playing on older, non-HD TV sets.

Shooting at the maximum frame size is by no means always essential. For example, 720p is the standard on Vimeo.com, the real home of quality video online, and will look excellent on most computer screens. VGA is suitable for playing on older, non-HD TV sets, and is fine for YouTube and many mobile devices, though the latest iPads have a 2048 x 1536 display, boasting more pixels than Full HD.

The lower settings allow you to record more video on the same memory card. A 4GB card will hold around 25 minutes of footage at the highest quality setting, 3 hours at the lowest. The P7700 produces movies in a standard Motion-JPEG format (the file extension is .MOV), compatible with standard media software like QuickTime and RealPlayer.

› Setting movie quality options

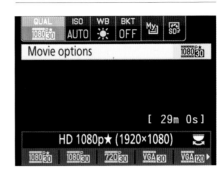

1) Set the Mode Dial to ▶🎥 or ▶🎥 MCS.

2) Turn the Quick Menu Dial to QUAL.

3) Select the desired option (see table).

4) Press **OK**.

Movie quality options

Option	Image size (pixels)	Quality	Frame rate/ playback speed	Available in mode
HD 1080p ★	1920 x 1080	High	30fps	Both
HD 1080p	1920 x 1080	Medium	30fps	Both
HD 720p	1280 x 720	Medium	30fps	Both
VGA	640 x 480	Low	30fps	▶🎥 Movie only
HS 120fps	640 x 480	Low	120fps (Slow-Motion)	▶🎥 Movie only
HS 60fps	1280 x 720	Medium	60fps (Slow-Motion)	▶🎥 Movie only
HS 15fps	1920 x 1080	High	15fps (Fast-Motion)	▶🎥 Movie only

6 » MOVIE MODES

There are two "movie" positions on the P7700's Mode Dial: 🎥 Movie and 🎥 MCS Movie Custom Setting. 🎥 Movie is a simplified Movie mode, a bit like using 🄰 Auto when shooting stills. 🎥 MCS offers you a number of extra options to give more control over the look and feel of the result. The table shows which options (in addition to Quality/frame rate) are available in each mode. The Movie menu occupies the top tab position on the Menu screen when the Mode Dial is set to 🎥 or 🎥 MCS.

Heading	Options	Location	Reference
Available in 🎥 Movie and 🎥 MCS> Movie Custom Setting			
Autofocus mode	AF-S Single AF AF-F Full-time AF	Movie menu	*See page 105*
Wind noise reduction	On Off	Movie menu	*See page 105*
White Balance	Full range as in still photography	Quick menu	*See page 37*
Focus mode	Full range as in still photography	▼	*See page 77*
Release	Normal (use shutter-release button) Remote	◄	*See page 43*
Available in 🎥 MCS> Movie Custom Setting			
ISO sensitivity	100–3200 + AUTO options	Quick menu	*See page 37*
Picture Control	Full range as in still photography	Quick menu	*See page 40*
Shooting mode	A, M, Special Effects	Movie menu	*See page 106*
Custom Picture Control	Full range as in still photography	Movie menu	*See page 106*
Built-in ND filter	On Off	Movie menu	*See page 106*
Available in 🎥 Movie only			
HS Movie (Slow Motion/ Fast Motion)	120fps; 60fps; 15fps	Quick menu	*See page 201*

» PRINCIPLES AND PREPARATION

In 🎥 **Movie** mode, you can dive right in and start shooting as key settings like ISO and exposure are automatic. 🎥 **MCS Movie Custom Setting** leaves you more choices to make. However, both modes do offer the same focusing options as stills photography, as well as control over white balance, and it's well worth thinking about these choices. The best default settings for you won't necessarily be the same as you'd use when shooting stills; this applies particularly to focusing.

TO THE BRIDGE ⩔
Manual focusing ensures the image is sharp where you want it and prevents any distracting shifts of focus.

› Focusing

Focus options for movie shooting are the same as in stills shooting and you access them in the same way. Pressing ▼ reveals the main options. If you select one of the Autofocus options, then there's a further choice, between **AF-S Single AF** and **AF-F Full-time AF**; choose between these in the Movie menu.

If **AF-F** is selected, the P7700 will automatically maintain focus while movie recording is in progress, though it may struggle with rapidly moving subjects. If **AF-S** is selected the camera will focus just once, when you half-press the shutter-

6

release button before starting to shoot the clip.

As movies often involve moving subjects, you might think **AF-F** would always be best, but shifts of focus are often uncomfortably obvious in the end result. Using a fixed focus for each shot is often perfectly viable, especially as depth of field is usually quite generous. The lower definition of the movie image, compared to stills, gives you even more leeway.

However, depth of field may not give you enough cover when subjects are moving towards or away from the camera, especially at close or mid-range and with a longer zoom setting. Here **AF-F** may be the better choice, but it doesn't always keep up with really fast-moving subjects.

Manual focusing is exactly the same as in still photography, if you use it to focus before you start shooting. You can shift focus manually in mid-shot as well, but now you don't see the magnified central area on screen. This makes it harder to focus precisely. However, if you plan carefully, you can occasionally use it to great effect, by staging a dramatic focus shift from a close subject to its distant background, or just from a blurred image (which might, for example, look good behind your opening titles) to a sharp one.

› Shooting modes

With the Mode Dial on ▶🎥 **MCS Movie Custom Setting**, the Movie menu gives you three choices for Shooting mode. If you select **Special effects**, you get the same choices as you do when shooting stills (except that **Zoom exposure** and **Defocus** during exposure aren't available).

The other **Shooting mode** choices are **A Aperture-priority** and **M Manual**. However, these don't allow you to change the key settings (ISO, aperture, shutter speed) while actually shooting a clip; you need to set them beforehand.

If you use M mode, you'll notice very quickly that you can't set shutter speeds slower than 1/30 sec. The reason should be obvious; if you're shooting 30fps you can't expect each frame to have a ½-second exposure!

In M mode, the exposure is fixed throughout each clip. If light levels

> ### Tip
>
> At default settings, pressing **AE-L/ AF-L** while you're recording a movie can have unwanted effects on focusing as well as locking exposure. To avoid this, either set this item in the Setup menu to **AE lock only**, or use Manual Focus.

change, this will be obvious in the footage. In A mode, the camera will adjust to varying brightness levels—but this will also often be obvious in the footage, and may not be welcome. If you want to keep the exposure level constant, press **AE-L/AF-L**; press again if you want to release the exposure lock.

› Exposure

In most movie shooting, exposure control is fully automatic and the camera adjusts for changing light levels by varying the shutter speed and/or the ISO rating. However, even in the simplified **🎥 Movie mode**, there are ways you can influence how the shot looks.

First, exposure level can be locked by pressing the **AE-L/AF-L** button, just as we've already mentioned in relation to A mode.

Second, you can use the exposure compensation dial; the range available is less than in stills photography, running from −2 to +2 Ev. However, nothing happens if you move the dial while shooting; you must set compensation beforehand. This allows you to achieve an overall high- or low-key effect throughout your clip (or even your entire movie), or to compensate when, for example, shooting a person against a bright background. The screen gives a rough preview of the effect and you could also shoot a short test clip.

› Slow and fast motion

In **🎥 Movie mode**, but not **🎥 MCS Movie Custom Setting**, you have the option to shoot slow-or fast-motion clips. Shooting at 15fps, for example, gives the effect of speeding everything up when played back at normal speed. You can do this at full HD resolution and high quality.

Conversely, shooting 60fps gives the effect of half-speed action when played back at 30fps; shooting at 120fps makes everything appear to speed up by a factor of 4. However, as you're asking the camera to record more and more frames, it's not entirely surprising that the resolution and quality decline in proportion. At 60fps you can record mid-quality 720p footage; at 120fps all you'll get is low-quality VGA.

Tip

You can speed up or slow down your clips in most movie-editing software too, without sacrificing quality.

6 » SHOOTING MOVIES

What should be clear by now is that preparation is key. Most, if not all, decisions about what you want to shoot need to be taken before you start shooting a clip. Then, when you do start shooting you can concentrate on what's actually happening in front of the lens.

If a still photo isn't quite right, you can review it, change position or settings, and be ready to reshoot within seconds. To shoot and review even a short movie clip eats up much more time, and you're that much less likely to get a second chance anyway. It's doubly important to get shooting position, framing, and camera settings right before you start. It's easy to check the general look of the shot by shooting a still frame beforehand, but this does not allow for movement of subject, camera, or both. If you're working with willing (or even paid) actors then doing several "takes" is par for the course, but this may not be an option if the action is outside your control. That historic steam train puffing across the Ribblehead viaduct isn't going to go into reverse to give you another go. It's worth rehearsing the shot as far as you can: can you pan smoothly and does the camera remain level, does the exposure look right?

If you're new to the complexities of movies, start with simple shots. Don't try zooming, panning, and focusing simultaneously; do one at a time. Many subjects can be filmed with a fixed camera: waterfalls, birds at a feeder, musicians playing, and loads more. Equally, you can become familiar with camera movements shooting static subjects: try panning across a wide landscape or zooming in from a broad cityscape to a detail of a single building.

› Shooting

1) Choose settings as above.

2) Check framing. Set initial focus and exposure by half-pressure on the shutter-release button (or focus manually).

3) Consider shooting a short test clip to check focus and exposure.

4) Press the shutter-release button fully to start shooting. **REC** flashes on the monitor screen, and an indicator shows the maximum remaining shooting time.

5) To stop recording, press the shutter-release button down fully again.

> ### *Tip*
>
> *If you're serious about movies, consider investing in a dedicated video tripod, or at least a tripod head. These are specifically designed to move smoothly.*

› Handheld or tripod shooting

Shooting movie clips handheld is a good way to reveal just how wobbly you really are. Using a tripod, or other suitable camera support, is the easiest way to give movie clips a polished, professional, look. Of course even "real" movie directors sometimes use handheld cameras to create a specific feel, but it isn't done lightly.

If you choose to handhold, or there's no tripod available, approach it carefully. Pick a spot where you won't be jostled and support the camera as firmly as possible, e.g. by sitting with elbows braced on your knees. And "think steady."

WATERWAY ≫
Exposure was set beforehand, which does mean there's some highlight clipping on the boat.

STEADY CAM ≫
Support the camera as firmly as possible.

› Panning

The panning shot is a movie-maker's staple. Often essential for following moving subjects, it can also be used with static subjects; for instance, sweeping across a vast panorama. Of course, landscapes aren't always static, and a panning shot combined with breaking waves, running water, or grass blowing in the breeze can produce beautiful results.

Handheld panning is very problematic; it may be acceptable when following a moving subject, but a wobbly pan across a grand landscape will definitely grate. You really, really need a tripod for this—and make sure it's properly levelled, or you may start panning with the camera aimed at the horizon but finish seeing nothing but ground or sky. Make sure you do a "dry-run" before shooting. Keep panning movements slow and steady. Panning too rapidly can make the shot hard to "read" and even nauseate the viewer. Smooth panning is easiest with video tripods, but perfectly possible with a standard model: leave the pan adjustment slightly slack. An extended handle on the tripod head is a great help in panning smoothly.

With moving subjects, the speed and direction of panning is dictated by the need to keep the subject in frame. Accurate tracking of fast-moving subjects is very challenging and takes a lot of practice.

SAIL AWAY ⌄
Level the tripod carefully or this can happen!

› Zooming

The zoom is another basic technique, and the P7700's powered zoom even gives it an advantage over current DSLRs. The digital zoom (*see page 31*) comes into its own when shooting movies as the loss of quality it causes isn't apparent in the lower-resolution movie image. However, the digital range is limited to about 2x (400mm equivalent).

Unfortunately, you can't zoom seamlessly from 28mm to the 400mm limit of the digital zoom. The zoom action stops at the end of the optical range (200mm) and you have to release and re-press the zoom lever to engage digital zoom.

Remember that depth of field (*see page 144*) decreases at the telephoto end of the range. Your subject may appear perfectly sharp in a wide-angle view but end up looking soft when you zoom in. Autofocus (if you're using *AF-F*) will probably handle this, but it's another thing that needs checking in "rehearsal".

HARBOUR SCENE　　　　　　　**»**
The same scene at 28mm, 200mm (the optical zoom limit), and 400mm (the digital zoom limit for movies).

6

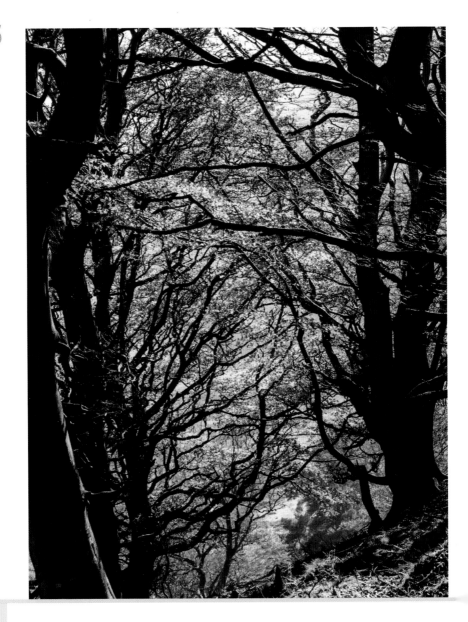

› Sound

The P7700's built-in microphone gives modest-quality sound, and is liable to pick up any sounds you make during operation (focusing, zooming, even breathing). You always have the option to add a new soundtrack later, but this is difficult if your film includes dialog or other specific sounds. If so, keep subjects close to the camera and ensure that background noise is minimized.

Fortunately the P7700 allows you to attach an external microphone (*see page 213*): plug in to a standard 3.5mm mini-jack socket under the cover on the left side of the camera. This automatically overrides the internal microphone.

There's basic sound-level control using the **External mic sensitivity** item in the Setup menu, but this is yet another thing that you must settle before shooting a clip.

› Lighting

For obvious reasons, you can't use flash. Low light levels may mean using a high ISO rating, with the inevitable increase in image noise—but, even at 1600 ISO, the fact that you can't use shutter speeds longer than 1/30 second puts a severe limit on the camera's night-shooting ability.

If you need to introduce additional lighting, there are now many relatively small and inexpensive LED light units, but they will only light the foreground.

EXPLORING THE SCENE **«**
The camera can "explore" a scene, either by zooming in from a wide shot to highlight specific aspects, or by panning across the scene to give a wider view.

6 » EDITING MOVIES

The P7700 doesn't shoot movies. Like all movie cameras, it shoots movie clips. Turning a jumble of clips into a real movie that's worth watching requires editing. The P7700's .MOV clips are a standard format, compatible with most available programs. Even better, there's no need for expensive software. Nikon Movie Editor is now part of the View NX2 package, supplied with the camera. It's not a highly featured app, but that means it's very easy to get started in movie editing without being bamboozled by endless choice of dissolves and effects.

For a bit more editing "oomph", there are other choices which shouldn't cost you anything. For Mac users the obvious choice is Apple's own iMovie, included with all new Macs. The Windows equivalent is Windows Movie Maker, available free from windowslive.com. A more advanced

Nikon Movie Editor

option is Adobe Premiere Elements (for both Macintosh and Windows).

With today's software, editing digital camera movies is almost easier to do than to describe. You don't have to use clips in the order you shot them (the fancy term is non-linear editing). You can also add other media to your movie, like still photos, a commentary, or music (with the copyright owner's permission, of course).

A bit of editing experience will also reinforce the value of forward planning. You might not write a complete shooting script, or a professional storyboard, but some advance thought, and a few notes about all the possible shots you might want, can be a great help.

› In-camera editing

You can't really edit movies in-camera, but you can extract sections of individual clips. It's a clunky procedure and it's always easier and more accurate to edit on the computer, but if you need access to a clip right away, the procedure is on page 28 of the Nikon Reference Manual.

Apple iMovie

Chapter 7
ACCESSORIES

7 ACCESSORIES

A wide choice of accessories is available for the P7700. Third-party items extend the options still further. Most of the really essential items are included with the camera, with a decent case being the most obvious omission.

» ESSENTIALS

› EN-EL14 battery

Without a live battery, your P7700 is useless deadweight. A spare battery is one of the first extra purchases you may consider. It's always wise to have a fully charged spare on hand—especially in cold conditions, when using the screen extensively, or when shooting movies. Incidentally, it's the same battery as used in the D3200 DSLR.

› MH-24 charger

This is vital for keeping the EN-EL14 battery charged and ready.

ESSENTIAL ACCESSORIES ⌃
The camera with EN-EL14 battery and MH-24 charger.

› Memory cards

The P7700 stores images on Secure Digital (SD), SDHC, and SDXC cards. On long trips it's easy to fill up even large-capacity memory cards, so it's advisable to carry spares—and they are now remarkably cheap. Fast card-write speeds accelerate the camera's operation and are important for movie shooting.

Tip

SD cards are tiny and easily mislaid. Though robust, they may not survive being trodden on or dropped into water. Cards loaded with irreplaceable images should be stored securely in the safest possible place.

» OPTIONAL ACCESSORIES

A selection from Nikon's extensive range is listed here.

› AC Adapter EH-5b

Together with a Power Connector EP-5, this can be used to power the camera directly from the AC mains, allowing uninterrupted shooting in, for example, long "studio" sessions. It may also be useful for lengthy playback sessions through a TV.

› External speedlights

See page 179.

› ME-1 stereo microphone

Greatly improves sound quality in movie shooting (*see page 207*).

› Wireless remote control ML-L3

This inexpensive little unit allows the camera to be triggered from a distance of up to 16ft (5m). When shooting stills you can use it to fire the shutter immediately or after a 1-, 2-, or 10-second delay. You can also use it to start and end the shooting of a movie clip. Alternatively, there's also a corded remote, the MC-DC2.

› HN-CP17 Lens hood

A lens hood (HN-CP17) is available separately. This helps protect the lens and also cuts down flare (*see page 160*) in some situations. It has a 58mm filter thread which allows filters and other additional accessories to be used; one example might be the Sunpak LED Macro Ring Light (*see page 190*).

› GPS Unit GP-1

Nikon's GP-1 GPS (Global Positioning System) Unit can be mounted on the hotshoe or clipped to the camera strap, and links to the camera's accessory terminal using a supplied cable. It allows information on latitude, longitude, altitude, heading, and Coordinated Universal Time to be added to image metadata. This information is displayed as an extra page of photo info on playback.

WIRE-FREE　　　　　　　　　　　　　　❯❯
The wireless remote control ML-L3.

› Converter lens

Designed for the P7700's predecessor, the P7100, Nikon's Wide-angle Converter WC-E75A turns the 28mm end of the P7100's zoom range into an effective 21mm lens. Sadly, this unit is not listed as being compatible with the P7700, although it is expected that Nikon may introduce a compatible converter or an adapter ring for this unit. An adapter ring would also allow filters and other accessories to be mounted on the P7700. Watch for announcements by Nikon and third-party manufacturers.

› Screen shades

This is not a Nikon product, but anyone who's struggled trying to frame or review pictures on the screen in bright conditions may well regard a screen shade as an essential extra. In the days when camera screens were much smaller, we've heard of people using the cardboard core from a toilet roll as an improvized shade, and no doubt you could still improvize something similar. However, there are many dedicated shades and loupes now available, of which the best-known is probably the Hoodman HoodLoupe.

HOOD »
A Hoodman HoodLoupe shown on a Nikon DSLR.

» FILTERS

The P7700's lens has a 40.5mm filter thread. Many standard photographic filters are available in this size, but they can be alarmingly expensive; if you already have some filters in a different size, a step-up ring allows these to be used. The HN-CP17 lens hood (*see page 213*) has a 58mm filter thread, providing another option. As well as individual screw-in filters, there are several systems which use square or rectangular filters, slotting into an adapter mounted on the lens. These make it easy to share filters across different cameras.

It's true that digital advances like white balance control make many filters much less necessary than they were when we all shot on film. The P7700's built-in ND filter is also useful (*see page 100*). Nevertheless, there are some filters, especially the polarizing filter, whose effect can't readily be mimicked digitally.

› UV and skylight filters

Both of these cut out excess ultraviolet light, which can make images appear excessively cool and blue. The skylight filter also has a slight warming effect. A major benefit is in protecting the front element of the lens.

› Polarizing filters

The polarizing filter cuts down reflections from most surfaces, intensifying colors in rocks and vegetation, for instance. It can make reflections on water and glass virtually disappear. The polarizer can also "cut through" atmospheric haze (though not mist or fog) like nothing else, and can make blue skies appear more intense. The effect varies as you change your angle on the subject or rotate the filter.

With wide-angle shots the effect can be conspicuously uneven across the field of view. The polarizer should be used with discrimination, not permanently attached. However, many of its effects cannot be fully replicated in any other way, even in digital post-processing. You may only use it occasionally, but then it can be priceless.

BLUE SKY THINKING ⌃
A polarizing filter can intensify colors (top/right side of image). *ISO 200, 35mm, 1/200 and 1/1000 sec., f/5.*

» STORAGE

› Neutral density filters

Neutral density (ND) filters reduce the amount of light reaching the lens, without causing a color shift. ND filters can be either plain or graduated.

A plain ND filter is useful when you want to set a slower shutter speed and/or wider aperture, and the ISO setting is already as low as it can go. A classic example is when shooting waterfalls, where a long shutter speed is often favored to create a silky blur. The P7700's built-in ND filter may be all you need for this.

Graduated ND filters ("grads") have neutral density over half their area, with the other half being clear, and a gradual transition in the middle. They are widely used to compensate for wide differences in brightness between sky and land. However, the straight transition can be unpleasantly obvious. This effect can often be replicated in post-processing, but not when shooting movies, where an ND grad is still an important standby.

TRAIN TIME »
Waiting for a train at Zurich Hauptbahnhof, I set the camera up on a handy barrier. The built-in ND filter helped me set a slow shutter speed. *ISO 80, 70mm, 1.3 sec. (beanbag), f/8 + built-in ND filter.*

› Portable storage devices

Memory cards rarely fail but it's always worth backing up valuable images as soon as possible. Usually this means backing up to your computer in the evening, but on holidays and other long trips this may not be possible.

Dedicated photo storage devices like the Jobo GigaVu or Wolverine PicPac series comprise a compact hard drive along with a small screen. However, more and more photographers are using devices they already own, such as an iPad or iPad Mini: you'll need an iPad Camera Connector. Apple devices will support RAW files, though you may need the latest version of the operating system. Android tablets will also store and display your images, though you may need additional apps, especially to handle RAW files.

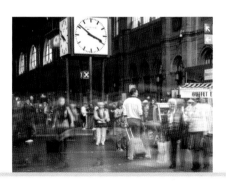

› Tripods

Vibration Reduction, plus the P7700's ability to produce decent images at high-ish ISO settings, do encourage handholding, but there are still many occasions where nothing replaces a tripod. Framing shots accurately while using the LCD screen is much easier on a tripod, too. While light weight and low cost always appeal, beware of tripods that simply aren't sturdy enough to provide decent support. With a lightweight camera like the P7700, in particular, they can also blow over in strong winds.

A good tripod is an investment that will last many years. The best combination of low weight with good rigidity comes (at a price) in titanium or carbon fiber. Carbon fiber tripods are made by Manfrotto and Gitzo, among others. The unusual design of the Benbo range gives great flexibility and they are popular with nature photographers for being able to shoot in awkward positions.

When shooting movies, a tripod is

essential, and many tripods are designed specifically for this purpose (*see page 203*).

The ingenious Gorillapod family don't have the height of a normal tripod but can stand firmly on many surfaces as well as attaching to fences, tree-branches and so forth.

› Other camera support

Monopods can't equal the ultimate stability of a tripod, but are light, easy to carry, and quick to set up.

There are many other solutions for camera support, both proprietary products and improvized alternatives. It's still hard to beat the humble beanbag; these can be home-made, or bought from various suppliers.

FULL OF BEANS ⏷
This home-made beanbag has served me well since pre-digital days.

CARRYING CASE ⏶
A very practical case from Think Tank Photo.

› Carrying the camera

Of course, the P7700 is more or less pocket-sized, but not every garment has suitable pockets, and you need to be careful as other items (e.g. keys and coins) can easily scratch the camera. A dedicated case provides greater protection and can be just as handy, if not more so. The most practical type is a simple drop-in pouch which you can wear on a waist-belt or rucksack-strap. Excellent examples come from makers like Think Tank Photo, Camera Care Systems, and LowePro.

Chapter 8
CONNECTION AND CARE

8 CONNECTION

In digital photography, connecting to external devices—especially computers—is not really an optional extra; it's how you store, organize, backup, and print images. Connecting to a Mac or PC also helps you exploit more of the potential of the P7700, including the ability to optimize image quality from RAW files. Today we can add tablet computers, especially the iPad, to the list.

» CONNECTING TO A COMPUTER

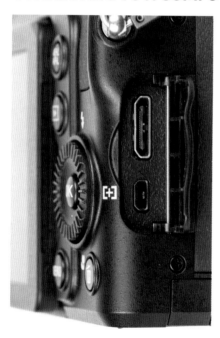

Connection ports on the right-hand side of the camera

› Computer requirements

Nikon View NX2 requires one of these operating systems: Mac OS X (Version 10.6.8 or later); Windows 7; Windows Vista (Service Pack 2); Windows XP (Service Pack 3). (Windows 8 support is inevitable but not yet confirmed.)

You'll need a USB port for connecting the camera, unless you connect wirelessly using an Eye-Fi card (*see page 228*). You can install Nikon View NX2 from the supplied CD or download from the Nikon website.

› Backing up

When you import images to the computer and then format the memory card for re-use, those images only exist in one place: the computer's hard drive. Any mishap to that drive—fire, theft, or hardware failure—could wipe thousands of irreplaceable images, so a backup is vital.

Apple's Time Machine maintains backups automatically

The simplest form of backup is to a second hard drive. Nikon Transfer can backup automatically during import.

› Connecting the camera

This description is based on Nikon Transfer, part of the supplied View NX2 package. The procedure with other software will be similar in outline but different in detail.

1) Start the computer and let it boot up fully. Open the cover on the camera's

Nikon Transfer 2

right side and insert the smaller end of the supplied USB cable into the USB/AV slot; insert the other end into a USB port on the computer.

2) Switch ON the camera. Nikon Transfer starts automatically (unless you have configured its Preferences not to do so).

3) The Nikon Transfer window offers various options; for full detail see the Help menu. The following are particularly important.

4) To transfer selected images only, use the checkbox below each thumbnail to select/deselect as required.

5) Click the **Primary Destination** tab to choose where photos will be stored. You can create a new subfolder for each transfer, rename images as they are transferred, and so on.

6) Click the **Backup Destination** tab if you want Nikon Transfer to create backup copies automatically during transfer.

7) Switch OFF the camera when transfer is complete, and disconnect the cable.

The procedure is broadly similar if you use a card-reader rather than connecting the camera directly.

» CONNECTING TO AN iPAD

Tip

*Always switch the camera **OFF** before connecting or disconnecting any cables.*

› Color calibration

A major headache for digital camera users is that images look one way on the camera monitor, different on the computer screen, different when you email them to friends, and different again when printed. For consistency across different devices, and reliable results when printing, your main computer screen must be correctly set up and calibrated. For detailed advice try searching System Help (or Google) for "monitor calibration".

Calibration software (this is the Display Calibrator Assistant in Mac OS X)

Unless you use Eye-Fi (*see page 228*), connecting to an iPad requires an Apple iPad Camera Connection Kit. This connects to the base of the iPad. The original iPad and iPad 2 use a 30-pin connector while newer models, including the iPad mini, use the smaller Lightning connector. The Connection Kit has two units, allowing you either to connect the camera directly via its USB cable, or to insert the memory card.

To import, launch the Photos app (if it doesn't launch automatically). This will quickly display thumbnails of all photos on the memory card. You can then **Delete All** or **Import All**. Or, if you tap a photo or photos, a checkmark will appear, and you can then delete or import just these photos. Imported photos will appear under **Last Import** in the **Albums view.** On completion, detach the Connection Kit.

» SOFTWARE AND IMAGE PROCESSING

Most of us want to do more with our images than simply store them. Backing up, printing, organizing, and making them look their best: all these require the right software.

Software choice depends partly on how you shoot. If you always shoot JPEG images, you may feel little need to tinker with them later. If you shoot RAW files, on the other hand, some image processing is essential—and the images themselves give you much more freedom to adjust tone, color and so on to your liking. See Image quality, *page 35*.

› Nikon software

The P7700 is bundled with Nikon View NX2 software. This includes Nikon Transfer (*see page 223*), a simple application that does a simple job competently. Nikon View NX2 itself covers most of the main processes in digital photography: you can view and browse images, save them in other formats, and print. View NX2 has a good range of tools for enhancing images (including RAW files), but is weak when it comes to organizing and cataloging.

Nikon Capture NX2 has much wider functionality but still feels awkward beside mainstream applications like Adobe Photoshop. Capture NX2 is not included with the camera and you will have to pay

to download it or obtain it on CD; before taking this step it is certainly wise to look at third-party alternatives (*see page 226*).

Using Nikon View NX2

1) From a browser view such as the thumbnail grid, click on an image to highlight it. **Image Viewer** shows the image in more detail, with a histogram, and **Full Screen** allows you to see the image full size.

2) Panels on the right side of the screen reveal **Metadata** (detailed info about the image), and the **Adjustment** palette, which allows a range of adjustments such as exposure and white balance. It also has access to Nikon Picture Controls (*see page 40*).

Nikon View NX2

Nikon View NX2 file format options

JPEG	Choose compression ratio: Excellent Quality; Good Quality; Good Balance: Good Compression Ratio; Highest Compression Ratio.	Suitable for immediate use. Choose Excellent Quality unless storage space is tight, or when images will only be used online.
TIFF (8-bit)		Creates larger files than JPEG but they stand up better to further editing; 16-bit is better still.
TIFF (16-bit)		The best choice when further editing is anticipated. Images can be converted to 8-bit after editing, halving file size.

3) Any adjustments you make will be recorded automatically. You do not need to export or convert the file immediately.

4) To export the file as a TIFF or JPEG that can be viewed, edited, and printed by most other applications, choose **Convert Files** from the **File** menu. You can resize and rename the image if required.

5) The **File Format** menu in the **Convert Files** dialog offers three options—see table above.

Note:
Older versions of most software, including NIkon's own, won't recognize RAW files created by the P7700; you will need to be up-to-date. On the other hand, older software generally handles JPEG files just fine.

> ## Third-party software

The undisputed monarch of image-editing software is Adobe Photoshop, the current version being Photoshop CS6. It's incredibly powerful—and it also costs more than the P7700 itself. (If you own an older version, upgrades are cheaper.) Many will find that Photoshop Elements, at a tenth of the price, has all the editing features they need, including the ability to open and edit RAW files from the P7700.

Photoshop Elements includes an **Organizer** module, which allows photos to be sorted into "Albums" and also "tagged" in different ways. Organizing or cataloging software becomes essential as you amass thousands of images, and View NX2 isn't much use for this.

Mac users have another excellent choice in iPhoto (latest version iPhoto 11: pre-loaded on new Macs). Like Photoshop Elements, it integrates organizing and

Adobe Photoshop Elements—the Organizer

editing abilities. There's no easier imaging software to grasp. iPhoto can open RAW files from the P7700, but ultimately Photoshop Elements does have the edge on editing power.

Dedicated RAW shooters are served by Apple's Aperture (Mac only) and Adobe Lightroom (Mac and PC). Both combine powerful organizing and cataloging with sophisticated and non-destructive image editing. "Non-destructive" means that changes to an image (color, density, cropping, and so on) are recorded as "notes" with the original RAW file. New TIFF or JPEG files, incorporating all the edits, can be exported as and when needed.

Lightroom costs substantially less than Nikon Capture NX2; it's a close rival in terms of RAW editing, but far superior when it comes to organizing and managing your image collection. Aperture is even cheaper, even undercutting Photoshop Elements: for Mac owners it's an absolute bargain.

EyeFi Center software

Once configuration is complete, insert the card in the camera. Use the **Eye-Fi Upload** item in the Setup menu and then the camera will automatically upload images as they are taken, as long as you remain within signal range of the network. The P7700 displays a notification when images are being uploaded.

Eye-Fi looks and operates like a conventional (albeit more expensive) SD memory card, but includes an antenna which enables it to connect to WiFi networks, allowing speedy wireless transfer of images to a computer.

Eye-Fi cards are supplied with a card-reader; when the card and reader are plugged into any recent Mac or PC the supplied software should install automatically. (Of course, the computer must also have a Wi-Fi connection.) There's then an automatic registration process which makes that computer the default destination for Eye-Fi upload. You can select a destination folder on your computer and you can also configure the system to automatically upload photos to sharing sites like Flickr.

Warning!

1) On most WiFi networks, uploading can be quite a slow process. It can certainly lag far behind the speed at which you can shoot images. Don't switch OFF the camera until images have finished uploading, although upload should resume when you turn it ON again.

2) Uploading by Eye-Fi is a drain on the battery. Even when beyond network range, the card will transmit in an attempt to connect. To preserve battery life, disable Eye-Fi upload when not using it.

» CONNECTING TO A TV

The supplied EG-CP16 cable is used to connect the camera to a normal TV or VCR. You can also connect the camera to an HDMI (High Definition Multimedia Interface) TV but you'll need an HDMI cable (not supplied: one end should be an HDMI Mini Connector, Type C). In other respects the process is the same.

1) Check that the camera is set to the correct mode in the Setup menu (NTSC or PAL—for standard TVs and VCRs—or HDMI).

2) Turn the camera OFF (important: always do this before connecting or disconnecting the cable).

3) Open the cover on the left side of the camera and insert the cable into the appropriate slot (AV-out or HDMI); connect the other end to the TV.

4) Tune the TV to the Video or HDMI channel.

5) Turn the camera ON by pressing the ▶ playback button. The camera's monitor will be blank; use the TV screen and navigate images or play movies in the usual way. The Slide show facility (*see page 107*) can be used to automate playback.

GET CONNECTED ❯❯
Connectors on the rear of a standard TV.

TV SHOW ❯❯
Displaying images on a standard TV.

» PRINTING

The most flexible and powerful way to print photographs from the P7700 is to transfer them to a computer. In this case the options are almost limitless and very much dependent on your choice of printer and of imaging software.

The memory card can also be inserted into a compatible printer or taken to a photo printing store. Finally, the camera can be connected to any printer which supports the PictBridge standard, allowing images to be printed directly.

Connecting directly to a printer

1) Turn the camera OFF.

2) Turn the printer on and connect the supplied USB cable. Open the cover on the right side of the camera and insert the smaller end of the cable into the USB slot.

> **Tip**
>
> *RAW images can't be printed directly from the camera, but you can use the NRW (RAW) processing item in the Playback menu to create a JPEG copy for direct printing.*

3) Turn the camera ON. You should now see a welcome screen, followed by a PictBridge playback display. There's now a choice between **Printing pictures one at a time** or **Printing multiple pictures**.

Printing pictures one at a time

This process is very straightforward, particularly if you are already familiar with navigating the P7700's playback screens.

1) Navigate to the photo you wish to print, then press **OK**. This brings up a menu of printing options—see the table. Use the Multi-selector to navigate through the menu and highlight specific options; press **OK** to select the highlighted option.

2) When the required options have been set, select **Start print** and press **OK**. To cancel at any time, press **OK** again.

Printing options

Option name	Options available (may vary according to printer)	Notes
Paper size	(For instance): 9 x 13cm 13 x 18cm A4	Options will be limited by the maximum size the printer can print.
Copies	1–9	Use ▲ / ▼ to choose number, then press **OK** to select.

Printing multiple pictures

You can print several pictures at once, with the option to print multiple copies

With the PictBridge menu displayed, press **MENU**. The options in the table on the following page are displayed.

Option name	Notes
Print selection	Use ◀/▶ to navigate pictures on the memory card (displayed as thumbnails). To see an image full screen, use the zoom control. To select the currently highlighted image for printing, press ▲. The picture is marked with a 🖶 and the number of prints set to 1. Press ▲ again to change the number of prints (up to 9). Repeat to select further images and choose the number of prints required from each. When selection is complete, press **OK** to display a screen showing total number of prints. Select **Start print** and press **OK**.
Print all images	Print one copy of each image in memory. Press **OK** to display a screen showing total number of prints. Select **Start print** and press **OK**.
DPOF printing	Print images already selected using the **Print set (DPOF)** option in the Playback menu (*see page 107*). Refresh your memory of the selected prints by choosing the **View images** option. Press **OK** to display a screen showing the total number of prints. Select **Start print** and press **OK**.
Paper size	Select paper size before choosing images to print.

NICE ICE »

Icy conditions provide lots of photographic opportunities, but also some challenges to the welfare of your equipment! *ISO 100, 28mm, 1/60 sec., f/5.6.*

» CARE

The P7700 is exceptionally rugged by compact camera standards, but still needs care to ensure it continues working reliably.

› Basic care

Use a simple hand-blower or a soft, dry cloth to remove dust and dirt, especially before opening the cover to change memory cards or batteries.

Take special care of the lens. Beware of knocks when the lens is extended. Avoid touching the front glass, and watch out for dust and dirt, especially larger particles, which could be swallowed when the lens retracts. Aim the camera downwards and clean carefully with a soft brush or hand-blower.

› Screen care

Avoid touching the screen as far as possible, and preferably stow it away fully when not in use. If you carry the camera round your neck, without stowing the screen, beware of buttons and zips that could cause scratches. Consider investing

in a screen protector: Nikon does not supply one but there are various third-party offerings.

When the screen needs cleaning, use a blower to remove loose dirt, then wipe carefully with a clean soft cloth.

› Coping with cold

Nikon specify a minimum operating temperature of 32°F (0°C). This does not mean that you can't use the camera when the temperature is below freezing, but try and avoid the camera itself getting chilled. Keeping it in a padded case (*see page 219*) between shots will help; or you can carry it under outer layers of clothing—but not too near your skin, as condensation can become a problem.

Cold severely reduces battery life; carrying a spare in an inside pocket may be a good idea. In extreme cold, the display

SPRAY AWAY ⋙
An exhilarating afternoon, but there was a lot of salt-spray! *ISO 200, 200mm, 1/1600 sec., f/8.*

may become sluggish or disappear, and ultimately the camera may stop working altogether. If warmed up *gently*, there should be no permanent harm.

› Heat and humidity

Extremes of heat (Nikon stipulate over 104°F or 40°C), and especially humidity (over 85%), can be even more problematic, and probably pose greater risk of long-term damage. Take particular care over rapid transfers from air-conditioned interiors to heat and humidity outside, which can lead to condensation within the camera. Pack the camera among sachets of silica gel, which absorbs moisture, and allow it to reach the ambient temperature before unpacking.

› Water protection

The P7700 does not claim to be waterproof, but a few drops of rain are unlikely to do any harm. However, keep exposure to a minimum, and wipe regularly with a microfiber cloth. Avoid using the built-in flash when it's wet. The hotshoe cover should also be in place (this is one of the easiest things to lose).

Take extra care around salt water; preferably avoid all contact. If the camera does get splashed, clean carefully with a cloth lightly dampened with fresh water.

Ideally, use a waterproof cover, like the

Aquapac range. When using these above the water surface, watch for splashes on the lens glass as these will be very obvious in the pictures.

› Storage

If the camera is unused for any length of time, remove the battery, close the battery compartment cover, and store in a cool, dry place. Avoid extremes of temperature, high humidity, and strong electromagnetic fields (which may be produced by TV and computer equipment).

BESIDE THE SEA ⌄
A waterproof case for the camera was essential on this trip. *ISO 400, 56mm, 1/500 sec., f/8.*

» GLOSSARY

8-bit, 12-bit, 16-bit: (*see* bit depth).

Aperture The lens opening that admits light. Relative aperture sizes are expressed in f-numbers (*see* f-number).

Artefact Occurs when data or data produced by the sensor are interpreted incorrectly, causing flaws in the image.

Bit depth The amount of information recorded for each color channel. 8-bit means that the data distinguish 2^8 or 256 levels of brightness per channel. 16-bit images recognize over 65,000 levels per channel, allowing more freedom in editing. The P7700 records RAW images in 12-bit depth and they are converted to 16-bit on import to a computer (*see* RGB).

Bracketing Taking a number of otherwise identical shots in which just one parameter (e.g. exposure) is varied.

Buffer On-board memory that holds images until they can be written to the memory card.

Burst A number of frames shot in quick succession; the maximum burst size is limited by buffer capacity.

Channel The P7700, like other digital devices, records data for three separate color channels (*see* RGB).

Clipping Complete loss of detail in · highlight or shadow areas (sometimes both), leaving them blank white or black.

CMOS (Complementary Metal Oxide Semiconductor) A type of image sensor used in many digital cameras, including the Nikon P7700.

Color temperature The color of light, in degrees Kelvin (K). Confusingly, "cool" (blue) light has a higher color temperature than "warm" (red) light.

CPU (Central Processing Unit) The small computer in the camera, and in many lenses, that controls most or all of the unit's functions.

dpi (dots per inch) A measure of resolution; should strictly be applied only to printers (*see* ppi).

Dynamic range The range of brightness from shadows to highlights within which the camera can record detail.

Exposure Usually refers to the amount of light hitting the image sensor, and to systems of measuring this.

Ev (exposure value) A standardized unit of exposure. 1 Ev is equivalent to 1 "stop" in traditional photographic parlance.

f-number Lens aperture expressed as a fraction of focal length; f/2 is the widest aperture on the P7700, f/8 the narrowest.

Fill-in flash Flash used in combination with daylight to lighten harsh shadows.

Filter A piece of glass or plastic placed in front of the lens to modify light.

Firmware Software which controls the camera. Upgrades are issued by Nikon from time to time.

Focal length The distance in mm from the optical center of a lens to the focal plane or sensor. On cameras like the P7700 focal length is stated as "equivalent" based on the 35mm film standard.

fps (frames per second) The rate at which photographs can be taken. The P7700's normal maximum rate is 8fps.

Highlights The brightest areas of the scene and/or the image.

Histogram A graph representing the distribution of tones in an image, ranging from pure black to pure white.

ISO (International Standards Organization) ISO ratings express the sensitivity of digital sensors.

JPEG (Joint Photographic Experts Group) A compressed image file standard. High levels of JPEG compression can reduce files to about 5% of their original size, but cause some loss of quality.

LCD (liquid crystal display) Flat screen like the P7700's rear monitor.

Macro Denotes close focusing, allowing photography of very small subjects.

Megapixel (*see* pixel).

Memory card A removable device on which images are stored.

Noise Random variations in pixel brightness and/or color giving images a grainy or speckled appearance.

Overexposure When too much light reaches the sensor, resulting in a too-bright image, often with clipped highlights.

Pixel Picture element: the individual colored dots which make up a digital image. One million pixels = 1 megapixel.

ppi (pixels per inch) In describing image files, more correct than the commonly used dpi.

Resolution The number of pixels for a given dimension, e.g. 300 pixels per inch. Often confused with image size. The native size of an image from the P7700 is 4000 x 3000 pixels; this makes a large print at 100 dpi (low resolution) or a smaller but finer one at 300 dpi (high resolution).

RGB (Red Green Blue) Digital devices record color in terms of brightness levels of the three primary colors.

Sensor The light-sensitive chip at the heart of every digital camera.

Shutter The mechanism which opens and closes to expose the sensor when the shutter-release button is pushed.

Shutter speed The length of time for which the shutter is open.

Spot metering A metering system which measures the light reflected by a small portion of the scene.

Underexposure When insufficient light reaches the sensor, resulting in a too-dark image, often with clipped shadows.

USB (Universal Serial Bus) A data transfer standard. The P7700 uses a USB cable to connect to computers and printers.

Viewfinder An optical system used for framing the image.

White balance A function which compensates for different color temperatures so that images may be recorded with correct color balance.

» USEFUL WEB SITES

NIKON-RELATED SITES

Nikon Worldwide
Home page for the Nikon Corporation
www.nikon.com

Nikon UK
Home page for Nikon UK
www.nikon.co.uk

Nikon USA
Home page for Nikon USA
www.nikonusa.com

Nikon User Support
European Technical Support Gateway
www.europe-nikon.com

Nikon Info
User forum, gallery, news, and reviews
www.nikoninfo.com

Nikon Historical Society
Worldwide site for study of Nikon products
www.nikonhs.org

Nikon Links
Links to many Nikon-related sites
www.nikonlinks.com

Grays of Westminster
Revered Nikon-only London dealer
www.graysofwestminster.co.uk

GENERAL SITES

Digital Photography Review
Independent news and reviews
www.dpreview.com

Thom Hogan
Real-world reviews and advice
www.bythom.com

Jon Sparks
Landscape and outdoor pursuits
photography
www.jon-sparks.co.uk

EQUIPMENT

Adobe
Photoshop, Photoshop Elements, Lightroom
www.adobe.com

Apple
Aperture and iPhoto
www.apple.com

Aquapac
Waterproof cases
www.aquapac.net

Think Tank Photo
Back packs, camera cases
www.thinktankphoto.com

Sigma
Independent lenses and flash units
www.sigma-imaging-uk.com / www.
sigmaphoto.com

PHOTOGRAPHY PUBLICATIONS

Photography books
www.ammonitepress.com/camera-guides.
html
Black & White Photography magazine,
Outdoor Photography magazine
ww.thegmcgroup.com

» INDEX

INDEX



NIKON COOLPIX P7700
THE EXPANDED GUIDE
SYMBOLS USED

- Multi-selector Up
- Multi-selector Down
- Multi-selector Left
- Multi-selector Right
- Delete button
- Close range only mode
- Macro close-up focus mode

- Infinity focus mode
- Movie mode
- Playback menu/Playback button
- Setup menu
- MENU Menu button
- Digital zoom limit
- Flash control

- Metering control
- Focusing control
- Self-timer
- Remote control
- Picture control
- Smile timer
- Auto mode
- Scene auto selector
- Portrait mode
- Landscape mode
- Sports mode
- Night portrait mode

- Party/indoor mode
- Beach mode
- Snow mode
- Sunset mode
- Dusk/dawn mode
- Night landscape mode
- Handheld
- Tripod
- Close-up mode
- Food mode
- Museum mode
- Fireworks show mode

- Black and white copy mode
- Backlighting mode
- Panorama
- Easy panorama
- Panorama assist
- Pet portrait
- Creative monochrome
- Painting
- Zoom exposure
- Defocus during exposure
- Cross process

- Selective color
- P Program mode
- S Shutter-priority mode
- A Aperture-priority mode
- M Manual mode
- Effects tab
- Auto-area AF mode
- Face-priority AF mode
- Manual area AF mode
- Normal area AF mode
- Wide area AF mode
- Subject tracking AF mode

- Target finding AF mode
- Matrix metering mode
- Center-weighted metering mode
- Spot metering mode
- AUTO Auto ISO
- ISO 200 ISO 80–200
- ISO 400 ISO 80–400
- ISO 800 ISO 80–800
- Single release mode
- Continuous H release mode

- Continuous M release mode
- Continuous L release mode
- Multi-shot 16 release mode
- Interval timer shooting
- Auto flash with red-eye reduction
- Slow sync
- Rear-curtain sync
- Manual
- Speedlight